Magic Lantern Guides

Canon
EOS REBEL 2000
EOS 300

Bob Shell/Heiner Henninges

**Magic Lantern Guide to
Canon EOS Rebel 2000/EOS 300**

Second Printing 2000
Published in the United States of America by

Silver Pixel Press®
A Tiffen® Company
21 Jet View Drive
Rochester, NY 14624
www.saundersphoto.com

From the original German edition by Heiner Henninges
Translated by Phyllis M. Riefler-Bonham
Edited by Bob Shell

Printed in Germany by Kösel, Kempten
www.KoeselBuch.de

ISBN 1-883403-62-6

Library of Congress Cataloging-in-Publication Data
Henninges, Heiner.
 Canon EOS Rebel 2000 (EOS) 300 / Heiner Henninges, Bob Shell.
 p. cm. -- (Magic lantern guides)
 Rev. ed. of: Canon EOS Rebel G, EOS 500 N. 1997.
 ISBN 1-883403-62-6 (pbk.)
 1. Canon camera Handbooks, manuals, etc. 2. Single-lens reflex
cameras Handbooks, manuals, etc. I. Shell, Bob. II. Henninges,
Heiner. Canon EOS Rebel G, EOS 500N. III. Title. IV. Series.
TR263.C3H463 1999
771.3'2--dc21 99-39068
 CIP

*This book is not sponsored by Canon, Inc. Information, data, and procedures are correct to
the best of the publisher's knowledge; all other liability is expressly disclaimed. Because
specifications may be changed by the manufacturer without notice, the contents of this
book may not necessarily agree with changes made after publication. Creative photogra-
phy is by Heiner Henninges, unless otherwise noted; photographs on pages 18, 20, 21, 31,
61, 76, 84, 129, 134, 135, and 136 by Bob Shell. We would like to thank Chuck Westfall
of Canon U.S.A., Inc., Camera Division, for offering his technical expertise to this book.*

Contents

Introduction

The Canon EOS Rebel camera (known as the EOS 1000 in most markets outside North America) was probably more responsible for introducing autofocus SLR (single-lens reflex) photography to a broad range of consumers than any other camera. Designed with fewer internal components than any SLR model previously made, the Rebel is small, lightweight, and easily operated. With this camera, Canon also introduced easy-to-access, subject-specific (PIC, or Programmed Image Control) programs and creative exposure programs. Subsequent models in the Rebel line still have these features.

The EOS Rebel camera, which was launched in 1990, was the first of many models in Canon's successful EOS Rebel camera series. Not long after, the EOS Rebel S (called the EOS 1000F in most markets outside North America) was introduced—a Rebel with a built-in flash.

Small, light, and simple: The Canon EOS Rebel XS (EOS 500).

In 1992, Canon introduced the second generation of Rebel cameras—the EOS Rebel II (EOS 1000N) without flash, and the EOS Rebel IIS (EOS 1000FN) with flash. These cameras were designed with minor improvements over the original models.

With the third generation of Rebel cameras, the EOS Rebel X and XS (EOS 500), introduced in 1994, Canon reduced the size and weight of the body, creating a very appealing, small autofocus SLR camera designed for the amateur photographer.

At Photokina 1996, Canon introduced the EOS Rebel G (EOS 500N), with evolutionary improvements such as manual focusing-point selection, Evaluative TTL (E-TTL) flash metering, autoexposure bracketing, and Night Scene mode. This model features a brighter viewfinder as well. The EOS Rebel G QD is a Rebel G with a Quartz Date back, which adds the capability of imprinting the date or time in the bottom-right corner of the picture; it is also available with a silver finish.

In 1999, at the Photo Marketing Association trade show in Las Vegas, Canon introduced the latest in the Rebel series, the most advanced model yet—the EOS Rebel 2000 (EOS 300). At the same time, in some markets outside the United States, Canon also introduced the simpler EOS Rebel 3000, which has three autofocus sensors instead of the seven in the Rebel 2000 (EOS 300).

Regardless of which Rebel 2000 model you own, this handbook, one of the *Magic Lantern Guides*, will help you understand how to use the features of your camera. The Early Rebel Models chapter, for example, clarifies important differences between models; other chapters offer guidance on camera operation. With chapters on each of the cameras' systems, flash use, accessories, and picture-taking hints, this handbook shows you how the innovative technology incorporated in the Rebel series can help you take consistently great pictures.

Note: These guidelines are written for the Canon EOS Rebel 2000 (EOS 300). Relevant differences in operation of the other EOS Rebel series models are noted in the text.

Terms and abbreviations are explained throughout this guide. When the terms "left" and "right" are used to describe the locations of the various camera controls, they refer to the position of the controls when the camera is held in the shooting position.

Early Rebel Models

Since 1990, Canon has introduced five generations of Rebel cameras. The original Rebel (EOS 1000) was offered without a built-in flash, but—as noted in the introduction—Canon soon introduced the Rebel S (EOS 1000F), which had this feature.

These original models were replaced two years later by the Rebel II (EOS 1000N), without flash, and the Rebel IIS (EOS 1000FN), with flash. These subsequent models are similar to their predecessors; the differences are that they have a Soft Focus mode, their top shutter speed was raised from 1/1000 to 1/2000 second, music plays during the self-timer countdown, and the film advance is significantly quieter.

The third-generation Rebel X and XS (EOS 500) cameras are smaller and lighter than previous Rebel models. These cameras feature three-point rather than one-point autofocus, a more auto-

Canon EOS Rebel G (EOS 500N)

mated A-DEP mode, and a greater selection of accessories than earlier Rebel models offered.

The fourth-generation Rebel G (EOS 500N) is similar to the Rebel X/XS, but includes refinements to the autofocus system and the addition of Evaluative-TTL (E-TTL) flash metering, autoexposure bracketing, and a Night Scene mode.

The fifth-generation Rebel 2000 (EOS 300) continues the trend toward more sophistication by incorporating seven autofocus sensors and 35-zone evaluative metering, plus other features previously found only on Canon's more advanced models.

Major differences between the generations of Canon cameras are given in the chart below:

Camera Model	Features
Rebel (EOS 1000), without built-in flash; Rebel S (EOS 1000F), with built-in flash	One-point autofocus. Three-zone metering system. Depth-of-Field mode. Top shutter speed: 1/1000 second.
Rebel II (EOS 1000N), without flash; Rebel IIS (EOS 1000FN), with flash	Faster top shutter speed (1/2000 second). Quieter film advance. Soft Focus mode.* Musical self-timer countdown.
Rebel X and XS (EOS 500)	Smaller and lighter. Three-point autofocus. Six-zone metering system. More automated Depth-of-Field (A-DEP) mode. Greater selection of accessories.
Rebel G (EOS 500N)	Similar to the Rebel X/XS. Refinements to the Autofocus system. Evaluative-TTL (E-TTL) flash metering. Autoexposure bracketing (AEB). Night Scene mode.
Rebel 2000 (EOS 300)	Seven-point autofocus; 35-zone evaluative metering. Other sophisticated features previously found only on Canon's more advanced models.

*Feature removed from later models.

Autofocus and Metering Systems

The Rebel (EOS 1000) and Rebel S (EOS 1000F) cameras have a single central autofocus sensor. This type of sensor is not a cross-type, and responds well only to subjects that run perpendicular to the sensor. When you encounter a subject that is difficult to focus automatically, you can usually achieve focus by switching the camera's orientation from horizontal to vertical (or vice versa) to enable the sensor to find focus. In addition to the single autofocus sensor array, these cameras use a three-zone metering system, far less versatile than the six-zone system of the Rebel G (EOS 500N), X and XS (EOS 500), and the highly advanced 35-zone metering used in the Rebel 2000. In spite of the simplicity of the Rebel and Rebel S cameras, however, the authors have found them to be quite functional and practical, producing a high percentage of properly exposed photos.

Battery Types

The different camera models use different battery types, listed in the following chart:

Model	Battery Type
Rebel 2000 (EOS 300)	Two CR2 lithium batteries or four AA batteries with the Battery Pack BP-200* accessory
Rebel X, XS, G (EOS 500 series)	Two CR123A lithium batteries or four AA batteries with the Battery Pack BP-8* accessory
Rebel (EOS 1000 series)	One six-volt lithium 2CR5 battery

*See accessories chapter for a description of the battery packs.

Depth-of-Field (DEP) Mode

The Depth-of-Field (DEP) mode in the first two generations of Rebel cameras (Rebel, Rebel S, Rebel II, and Rebel IIS [EOS 1000 series]) sets an aperture that will produce the depth-of-field range you specify. First, set the Command Dial to DEP. Place the autofocus sensor in the viewfinder on the area you want to be the closest part of the depth-of-field range. Once this area is targeted, press the shutter release button partway down. The LCD panel and the viewfinder will display "dEP-1" as confirmation. Repeat this step for the farthest limit of the range; the camera will then display "dEP-2." At this point, press the shutter release partway down again. The aperture that will yield the desired depth of field is displayed on the LCD, and the lens is automatically set for the hyperfocal distance for the desired range of focus. Pressing the shutter release button down all the way takes the photo. It is important to pay attention to the shutter speed displayed, as it will often be too slow for hand-holding when great depth of field is desired. In this case, use a tripod or other camera support.

When using zoom lenses with DEP mode, you must first adjust the lens' focal length and then make the two distance settings. If you change the focal length after setting one distance, the first setting will be canceled and you must start over.

This mode is different from the A-DEP mode on the Rebel X/XS and G (EOS 500 series), and Rebel 2000 (EOS 300/3000), which automatically sets an aperture that will produce sharp focus for the subjects that fall within the focusing points: Simply set the Command Dial to A-DEP and press the shutter release partway down to focus automatically on the main subject. Verify the shutter speed and aperture in the viewfinder, and press the shutter release all the way to shoot the picture. (See page 68 for more information.)

Musical Self-Timer

The Rebel II and IIS (EOS 1000N and 1000FN) cameras feature a selection that is represented by a musical note on the Command Dial. When the Command Dial is set to this position, the Main Dial can be used to select a number from 1 to 4 on the LCD

panel. The first setting, 1, represents a simple beeping tone. The others correspond to musical compositions by Vivaldi (2), Beethoven (3), or Bach (4). This music, more pleasant to the ear than a beeping tone, was chosen to encourage people to smile for their photo. By setting the desired number, you can select either the tone or the short melody to be played during the self-timer's countdown. You can "preview" the tunes by lightly touching the shutter release button with the camera set to any of the four settings.

Canon EOS Rebel IIS (EOS 1000FN)

Soft Focus Mode

In the opinion of author Bob Shell (who specializes in glamour photography), the Soft Focus mode in the Rebel II and IIS (EOS 1000N and 1000FN) cameras is highly useful in such work. This unique mode, which allows pleasing soft focus photos to be taken with any Canon EF (electronic focus) lens, has been omitted from later Rebel models—an unfortunate change, in Shell's view, as this distinctive feature makes the Rebel II and IIS the

ideal glamour photographer's camera. Shell has enthusiastically recommended the Rebel II and IIS to aspiring glamour photographers since their introduction.

To use the Soft Focus mode, set the Command Dial to the SF position, and use the Main Dial to select either a 1 or 2 on the LCD panel. These adjustments yield two different degrees of soft focus: 1—slightly soft, 2—very soft. Once you select the desired soft focus effect, simply compose the picture and shoot. (Only shutter speeds faster than 1/4 second can be used in this mode.) The camera then fires two shots in rapid succession on the same frame of film. The first exposure is taken in normal sharp focus, and the second is made with the lens thrown slightly out of focus. The overlay of sharp and soft images produces a wonderful soft focus effect that cannot be obtained in any other way. The camera also adjusts the exposure automatically so that the two exposures combine to produce one correctly exposed image.

Because the two images are taken in rapid succession—but not instantaneously—it is best to use a tripod or other camera support and work with subjects who can hold still for the short time it takes to complete the two exposures (about one second at most shutter speeds).

All Rebel cameras are remarkably versatile, belying their very reasonable price and their outstanding picture quality. While not as rugged as the more professional EOS cameras, when used with Canon EF lenses they can produce pictures every bit as good as those taken with other EOS models.

Canon EOS Rebel 2000 Operation

The Canon Rebel 2000 (EOS 300) is a small, lightweight, autofocus SLR camera with a built-in flash. It is as easy to handle as a fully automatic compact (point-and-shoot) camera and can be used with the entire line of Canon EF lenses and many EOS accessories.

The Rebel 2000 offers everything a photographer might want in a modern autofocus SLR camera:

❏ Seven-sensor, selectable autofocus, plus manual focus
❏ 35-zone evaluative metering, partial metering, and center-weighted average metering
❏ The Image Zone: six subject-specific programs—Full Auto (Green Zone), Portrait, Landscape, Close-Up (macro), Sports, and Night Scene Program Image Controlled (PIC) modes
❏ The Creative Zone: five exposure modes for artistic expression—Program (P) Autoexposure (AE), Shutter-Priority (Tv), Aperture-Priority (Av), A-DEP, and Manual
❏ Electronic shutter with speeds ranging from 1/2000 second to 30 seconds, plus Bulb setting
❏ TTL, A-TTL, E-TTL, FE Lock, and High-Speed Sync Flash modes

Because of its fully automatic functions, the EOS Rebel 2000 prevents blurry pictures due to camera shake, and even makes fill flash easy to use.

To suit the needs of amateur photographers, this camera has fewer switches and buttons than many other EOS models. All relevant exposure information is visible on the external LCD panel and, when the camera is turned on, on the viewfinder display.

The Rebel 2000's design keeps to a minimum the number of steps required before shooting a picture. It features Canon's AIM

◁ **The Rebel 2000's ease of use allows you to concentrate on form, texture, light, and compositional elements to make an arresting photograph.**

Canon EOS Rebel 2000 (EOS 300)

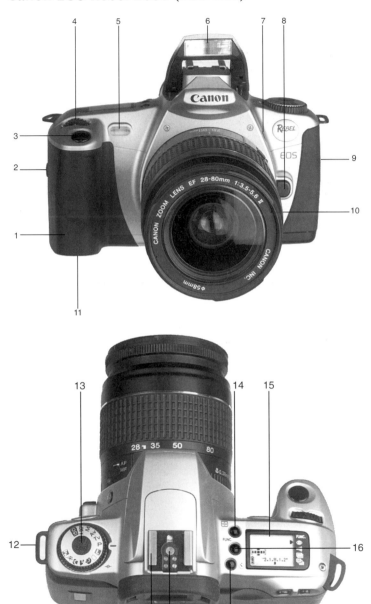

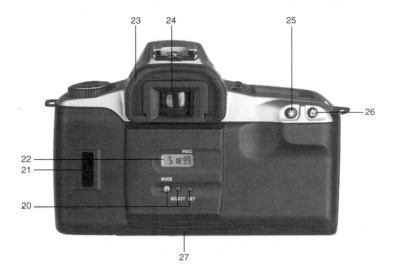

The EOS Rebel 2000 QD has a date and time imprint feature and a silver finish.

1. Grip (battery compartment)
2. Remote control terminal
3. Shutter button
4. Main Dial
5. Red-Eye Reduction/Self-timer lamp
6. Built-in flash/AF assist beam emitter (retractable)
7. Flash button
8. Lens release button
9. Camera back lock-release lever
10. Depth-of-field preview button
11. Battery compartment cover lever
12. Strap attachment eyelet
13. Command Dial
14. Focusing point selector
15. LCD panel
16. Function button
17. Self-timer button
18. X-sync contact
19. Hot shoe
20. Date buttons
21. Film window
22. Quartz date display panel
23. Eye cup (retractable)
24. Viewfinder
25. Partial metering/AE lock/ FE lock button
26. Exposure compensation/ Aperture button
27. Tripod socket

Command Dial

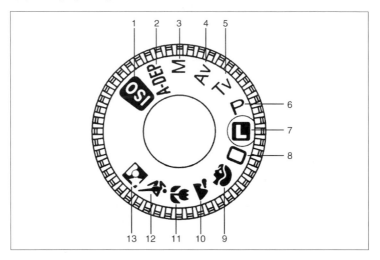

1. Manual ISO film speed
2. Automatic depth-of-field AE
3. Manual exposure
4. Aperture-Priority AE
5. Shutter-Priority AE
6. Intelligent Program (P) AE
7. Lock (Off)
8. Full Auto (Green Zone)
9. Portrait
10. Landscape
11. Close-Up (macro)
12. Sports
13. Night Scene

(Advanced Integrated Multipoint) control system, which detects the position of the subject automatically and focuses and meters the scene accordingly. (Or, you can select a focusing point manually and meter on a specific area of the frame.) In Full Auto mode, all you really need to do is frame the subject and shoot. But if you want to shoot using a fast shutter speed or experiment when you come upon an interesting situation, you can also use one of the camera's many program options, which extend the camera's range of creative possibilities. (See the chapter on choosing an exposure mode.)

Together with the standard EF 28-80mm f/3.5-5.6 zoom lens, the Canon EOS Rebel 2000 weighs just 18.5 ounces (524 g). With this camera, you're well equipped for most picture-taking situations, including landscapes, formal portraits, and even high-speed snapshots. Its portability and user-friendly design make the EOS Rebel 2000 fun to use while you're taking great photos.

Camera Controls and Features

The Command Dial

The Command Dial, on the upper left of the camera, offers 13 settings in four sections: L (lock); the Image Zone (six subject-specific modes); the Creative Zone (five creative modes); and ISO (manual film speed setting):

1. The L in the red box on the Command Dial stands for Lock. When the dial is set in this position, the camera's power is off.

2. The Image Zone begins with the green rectangle below the L and includes the next five icons. The rectangle is the setting for Full Auto (Green Zone). The five icons below Full Auto mode represent the other Image Zone modes—Portrait, Landscape, Close-Up (macro), Sports, and Night Scene—which are designed for shooting specific subjects and situations. In Full Auto mode, the EOS Rebel 2000 controls all functions automatically. The camera determines aperture and shutter speed and adds flash if necessary. In this mode, when focus is correct, a beeper sounds and a green LED lights at the base of the viewfinder.

3. Above the L on the Command Dial are settings for the five modes of the Creative Zone: Program (P) Autoexposure (AE), Shutter-Priority AE (Tv), Aperture-Priority AE (Av), Manual (M), and Automatic Depth of Field (A-DEP).

4. The ISO position, marked in silver, is used to set the film speed manually (see page 33).

Shutter Release Button

The EOS Rebel 2000 has a two-stage shutter release button on the

Light pressure on the shutter release button activates the camera's electronics. Added pressure trips the shutter.

top of the grip. Just a slight touch of this button (pressing it only partway down) activates the camera's entire electronic system:

❏ The autofocus system focuses the lens automatically. A green LED in the viewfinder and a short beep verify that focusing has been successful. (The beep can be turned off.)
❏ Red-Eye Reduction is activated if the function is enabled.
❏ The shutter speed and the aperture are indicated on the LCD panel.
❏ When the shutter release button is pressed all the way down, the picture is taken and the film advances to the next frame automatically.

Film Advance
An integrated micro motor advances the film automatically for individual or series shots, depending on the mode selected. For series shots, you must hold down the shutter release button continuously, and the camera advances the film at one frame per second. For individual shots, you press the shutter release button once for each shot.

In Full Auto, Landscape, Close-Up, Night Scene, and A-DEP modes, continuous film advance is not available, and photos must be taken one at a time. Continuous film advance is possible in all other modes.

The EOS Rebel 2000's Whisper Drive Film Transport is so quiet that pictures can be taken in situations where a camera motor's noise would otherwise be disturbing.

The Main Dial
This feature, located directly behind the shutter release button, is typical of the practical ease designed into Canon EOS cameras. Depending on the exposure mode desired, it can be used by itself

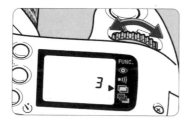

The Main Dial allows you to set aperture, shutter speed, and other exposure variables.

or with other camera controls to input information appropriate to the selected exposure mode.

Note: The camera's computer retains the most recent settings, even after the camera has been turned off.

In Manual mode, use the Main Dial to select the shutter speed and the aperture value. To adjust the shutter speed, just turn the dial. To adjust the aperture, press the Av +/– button on the camera's back and turn the dial. In Program mode, turning the Main Dial shifts the automatically selected shutter speed and aperture combination either toward faster shutter speeds and wider apertures or toward slower shutter speeds and smaller apertures. In Shutter-Priority (Tv) mode, the Main Dial changes the shutter speed. In Aperture-Priority (Av) mode, the Main Dial changes the aperture.

To set the exposure compensation value in P, Tv, Av, and A-DEP modes, turn the Main Dial while pressing the exposure compensation (Av +/–) button. The Main Dial is also used to set the film speed manually when the Command Dial is set to ISO.

Function Button
The Rebel 2000 has a function button on the top of the camera, next to the LCD panel. When used with the Main Dial, the function button activates and deactivates Red-Eye Reduction, in-focus beeper, multiple exposure, and autoexposure bracketing (AEB) functions. (See corresponding sections in this chapter and in the chapter on choosing an exposure mode.)

The function button and Main Dial allow you to control features that include Red-Eye Reduction, in-focus beeper, multiple exposures, and autoexposure bracketing (AEB).

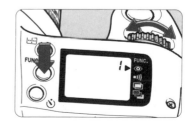

Red-Eye Reduction

Red-eye results when light from the electronic flash is reflected off the subject's retina into the lens. Red-eye can occur in a wide range of circumstances, but is most common when photographing fair-eyed people and pets. The Rebel 2000's Red-Eye Reduction feature helps prevent red-eye in shots taken of people and animals in a relatively dark environment. To use Red-Eye Reduction:

1. Press the function button until the arrow points to the red-eye symbol in the LCD panel.
2. Turn the Main Dial and change the display from 0 to 1.
3. Press the shutter release bulb partway down. The krypton lamp on the front of the camera will light up, and the built-in flash will fire a pre-flash burst before the camera's shutter fires.
4. To take the picture, press the shutter release button all the way down. The bright light will cause the subject's pupils to close, minimizing the chances of the eye's red retina appearing in the picture.
5. To deactivate the Red-Eye Reduction feature, press the function button until the arrow points to the red-eye symbol, and turn the Main Dial until the display reads 0.

In-Focus Beeper

When a subject within the area of the active autofocusing point is in focus, a beeper sounds to confirm focus. This beeper can be turned off in all modes.

❏ To turn the beeper on: Press the function button until the arrow next to the beeper symbol is lit, and turn the Main Dial until the display reads 1.

❏ To turn the beeper off: Press the function button until the arrow next to the beeper symbol in the LCD panel is lit. Then turn the Main Dial until the display reads 0.

Focusing Point Selector

In all Creative Zone modes except A-DEP, the active focusing point can be selected manually. (This cannot be done in any of the Image Zone modes.) To select a focusing point, press the focusing point selector, located to the left of the LCD panel, and then turn the Main Dial. The selected focusing point will appear at the bottom of the viewfinder and on the LCD panel on top of the camera.

Self-Timer

The self-timer can be used with any program. To activate, press the button with the clock symbol, located to the left of the LCD panel; the self-timer symbol is then displayed in the LCD panel. When you're ready, press the shutter release button. The krypton lamp lights up during the last two seconds before exposure; assuming that focus has been achieved, exposure takes place 10 seconds later.

To cancel the self-timing cycle, press the self-timer button a second time, or turn the Command Dial to L.

Partial Metering/AE Lock/FE Lock Button

The partial metering button (marked with a star on the back of the camera) allows you to spot meter about 9.5% of the image area, indicated by the autofocus point in the center of the viewfinder. When partial metering is operating, a green star lights in the viewfinder display.

To take a picture using partial metering: Center the subject in the viewfinder; press the partial metering button; recompose the frame (if necessary); and press the shutter release button. The exposure settings are locked until the picture is taken or for four seconds after the partial metering button is released, whichever comes first.

Exposure Compensation/Manual Aperture Setting (Av +/–) Button

The Av +/– button, located on the back of the camera, has two functions: to adjust the aperture setting in Manual mode when used with the Main Dial, and to set exposure compensation in 1/2 stops up to +/– 2 EV (exposure values) in other Creative Zone modes (P, Tv, Av, and A-DEP).

Exposure compensation cannot be set in any Image Zone (subject-specific) mode.

Note: Existing exposure-compensation settings are temporarily disabled when the camera is set to Manual mode, and are canceled when the camera is set to an Image Zone mode.

Flash Button

Should lighting conditions require it, the camera's built-in flash pops up automatically and fires in the following Image Zone

modes: Full Auto, Portrait, Close-Up, and Night Scene. To use the built-in flash in the Creative Zone modes, you must press the flash button, located to the left of the lens mount, above the lens release button. This button makes the flash unit pop up.

Autofocus Assist Beam
If lighting conditions are such that autofocus is not possible, the autofocus (AF) assist beam (the same krypton lamp that acts to reduce red-eye) projects a beam of light on the subject, allowing the camera to focus automatically. The beam reaches about 15 feet (5 m).

If any EOS-dedicated accessory flash unit other than the Speedlite 380EX, 540EZ, or 550EX is mounted, the camera's AF assist beam operates—except when the central focusing point has been selected manually. When any of these units is used, its AF assist beam overrides that of the camera's.

Depth-of-Field Preview
The Rebel 2000 is the first Rebel model to feature a depth-of-field preview button. This button stops the lens down to the taking aperture when it is pressed, allowing visual evaluation of depth of field in the viewfinder. Depth-of-field preview works only in the Creative Zone modes.

Lens Release Button
To detach the lens, press the large button next to the camera bayonet, rotate the lens counterclockwise (to the left as you face the camera), and lift the lens off.

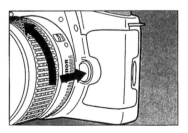

The lens release button is located at three o'clock as you face the camera.

Remote Control Terminal
A jack for using the Canon Remote Switch RS-60E3 (available as an accessory; see accessories chapter) is located on the right end of the camera, and is protected by a plastic cap when not in use.

Canon EOS Rebel 2000 (EOS 300) LCD Panel

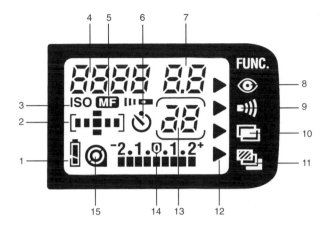

1. Battery level indicator (4 levels)
2. Focusing point indicator (camera or user selectable)
3. ISO symbol
4. • Shutter speed setting (2000 to 30", bulb)
 • ISO film speed/Numeric display (6-6400)
5. Manual focus symbol
6. Self-timer symbol
7. • Aperture display (0-91)
 • Red-Eye Reduction setting (0, 1)
 • In-focus beeper mode display (0, 1)
 • AEB amount display (0.0-2.0 in 1/2-stop increments)
8. Red-Eye Reduction symbol
9. Beeper symbol
10. Multiple-exposure symbol
11. AEB symbol
12. Function pointers

13. • Frame counter (1-36)
 • No. of multiple exposures set (1-9)
 • No. of multiple exposures remaining (1-9)
 • Self-timer countdown (10-1)
 • Wireless remote control delay countdown (2-1)
14. Exposure level scale
 • Exposure compensation amount
 • Metered manual exposure level
 • AEB amount
 • Red-Eye Reduction lamp-on indicator
15. Film status
 • Film loaded
 • Film rewind completed/AL failure

Canon EOS Rebel 2000 (EOS 300) Viewfinder Display

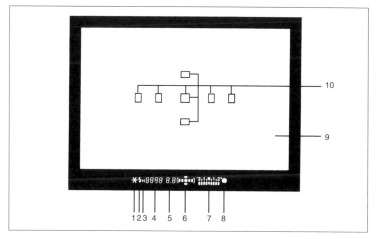

1. AE/FE lock indicator
2. Flash-ready indicator
 - Insufficient-flash warning (during FE lock)
3. High-speed sync FP flash indicator
4. Shutter speed display (2000 to 30", bulb)
5. Aperture display (0-91)
6. Focusing point indicator
7. Exposure level scale (0.0-2.0 in 1/2-stop increments)
 - Exposure compensation amount
 - Metered manual exposure level
 - Red-Eye Reduction lamp-on indicator
 - AEB amount
 - Focusing point indicator
8. In-focus indicator
 - Lights when focus is achieved in One-Shot AF; blinks at 2Hz if focus fails
 - Lights when manual focus is achieved (Focus Aid indicator); off when manual focus is not achieved (no Focus Aid indicator)
9. New laser-matte screen
10. Focusing points (sensors)—not superimposed

Information Displays

LCD Panel

The Rebel 2000's LCD panel is located on the top of the camera. At a glance, you can check (among other information) exposure values, active focusing point, exposure compensation, multiple exposures, and the number of frames still available. The battery level is also indicated.

Viewfinder

The Rebel 2000's viewfinder screen is 10% brighter than that of the Rebel X/XS. The LED display, at the bottom of the viewfinder frame, shows exposure and focus information in an easy-to-read format. The focusing points are etched on the viewing screen

Loading Batteries and Film

Battery Compartment

To replace batteries in all Rebel models, open the battery compartment by pushing out on the battery-cover lever, located on the base of the camera's hand grip. The Rebel 2000 uses two lithium CR2 batteries. (See page 14 for battery requirements for earlier models.) To insert the batteries properly, be sure to observe the + and – markings.

Load the batteries into the battery compartment as shown on the cover. Photo by Bob Shell.

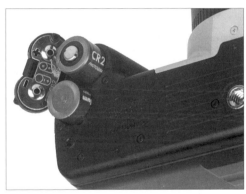

Loading Film

To load film into the Rebel 2000:

1. Turn the camera on by setting the Command Dial to any position other than L.

2. Open the camera back by pushing up on the latch on the left side of the camera.

3. Slip the film into the cassette compartment on the left. This process is easiest when you insert the bottom of the cassette (the end with the protruding spool) first, making sure that the small red pin inside the compartment fits into the hole in the film-cassette spool, and then pushing the entire cassette into the compartment.

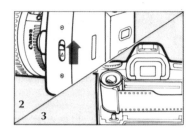
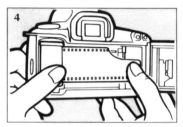
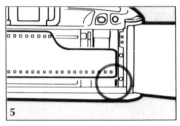

Loading Rebel-series cameras is very simple. With DX-coded film (1), the camera automatically sets the correct film speed. Refer to the text for details on the proper loading procedure (2-5).

Caution: Take care not to touch the delicate shutter blades, because damage could occur.

4. Pull the film leader up to the red mark at the base of the take-up chamber (at right).
5. Close the camera back by applying gentle pressure. When the camera back is closed, the camera will automatically wind the entire roll of film forward into the take-up chamber.

As pictures are taken, the Rebel 2000 rewinds the film one frame at a time, safely storing the exposed frame within the cassette as soon as the exposure has been made. The only disadvantage of this system is that the numbers of the film frames are in reverse order from the one in which the photos were taken. The frame counter on the LCD panel indicates the number of frames that are still available.

If there is no film in the camera, the film-loaded symbol does not appear on the LCD panel. Otherwise, this symbol is visible even when the camera is switched off.

Setting Film Speed Manually

An ISO position is marked in silver on the Command Dial. This setting permits you to input the film speed manually by turning the Main Dial. Normally, the film speed is set automatically using DX coding from ISO 25 to 5000 in 1/3 stops. Setting the film speed manually gives you speeds ranging from ISO 6 to 6400 in 1/3 stops. Manually set film speeds are retained for only one roll of film, and must be reset each time film is changed.

Rewinding Film

When a roll of film has been completely shot, the Rebel 2000 automatically transports the rest of the film back into the cassette. You can rewind a partially exposed roll of film, however. To do this, press the mid-roll rewind button, located on the left end of the camera, below the back latch. The film will then wind completely into the cassette.

If you want to shoot the unexposed frames at a later date, note the number of the last frame exposed, write it on the cartridge, and use a film-leader retriever (available at most photo stores) to pull the leader out of the cartridge. Then follow these steps: Reload the cassette, set the exposure mode to Manual, set a fast shutter speed, set the lens to Manual focus, put the lens cap on, and fire the camera until the roll has reached one frame past the last frame exposed. Then shoot the rest of the roll as usual.

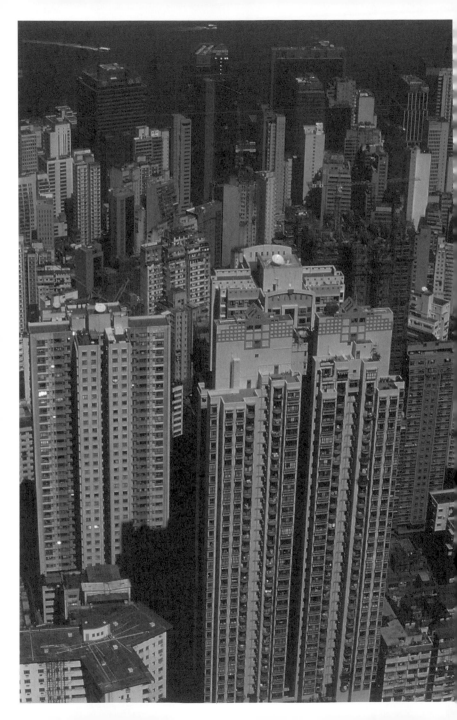

The Focusing System

The Canon EOS Rebel 2000 camera uses a special "Multi-BASIS" (Base-Stored Image Sensor) automatic focusing system. This system uses the TTL-SIR (through the lens–secondary image registration) principle: the camera determines focus by performing measurements through the lens using BASIS, which detects the phase shifts of two partial images similar to the way used by earlier split-image rangefinders. The AF microprocessor uses the deviation between the partial images to compute the direction and magnitude of the required focusing adjustment.

As shown on the diagram of the viewfinder, the camera has seven focusing points, or sensors: six are to the right, to the left, and above; below is the seventh, a central cross-type focusing sensor. You can align your main subject with any of these seven sensors, and the camera will focus on it quickly and accurately. The beauty of this system is that important image details do not necessarily have to be located in the center of the image to be in focus, and the AF system can recognize and follow subjects that are moving parallel to the film plane in both horizontal and vertical compositions.

Note: EOS Rebel cameras include a focus default, which allows the camera to be fired only when the subject is in correct focus.

The Rebel 2000 offers manual focus and two autofocus (AF) modes: One-Shot and AI (artificial intelligence) Servo (self-adjusting, using continous sensor information). The camera automatically chooses between the two autofocusing methods, based on the picture-taking situation.

◁ **Because it uses Canon's cross-type sensor, the Rebel 2000 can autofocus on both horizontal and vertical subjects.**

Autofocus Modes

One-Shot Autofocus

In One-Shot AF mode, the focus is adjusted and stored for a subject that is within the active focusing point when the shutter-release button is pressed lightly. Whether you are using evaluative or partial metering, the exposure value is stored when focus is achieved. One-Shot AF mode is used in Portrait, Landscape, Close-Up (macro), Night Scene, and A-DEP exposure modes.

If the Rebel 2000 camera is in One-Shot AF mode and detects subject movement, however, it automatically switches to AI Servo mode (see below). This automatic switching—done through a feature called AI Focus, which adjusts the focus continuously as it senses movement—allows the predictive (anticipatory) AI Servo mode to function. The camera, usually picking the closest focusable subject, attempts to determine correct focus by evaluating all seven focusing points when the shutter release is pressed partway down. After the lens is focused, AI Servo mode continues to monitor the subject as long as the shutter release button remains lightly pressed.

AI Servo AF

AI Servo AF mode decides automatically, based on the subject's movement and independently of photographer input, whether the focus value should be stored or updated.

AI Servo AF mode keeps constant focus on moving subjects. When the shutter release button is pressed halfway, the AF mechanism is activated. In AI Servo AF mode, the AF measuring system is continuously active, automatically recognizing a subject's movement within the measuring field. The data collected by the camera's predictive focusing algorithm allows the AF microprocessor to calculate the speed of motion and to predict the position of the subject at the precise moment the shutter is opened. Therefore, despite the delay between the time the shutter release is pressed and the time the actual exposure is made, even subjects that move rapidly at an angle from the camera are photographed perfectly in focus. This is the AF mode used in Sports mode.

Autofocus and Individual Exposure Modes

Whether the camera uses One-Shot or AI Servo autofocus is a

function of each of the EOS Rebel 2000's exposure modes. In any autofocus mode, a picture can be taken only if the camera can focus on the subject. (For more information, see the chapter on exposure.)

Selecting a Focusing Point

All Creative Zone modes, except A-DEP, use One Shot AF. In any Creative Zone mode, the focusing point can be selected either automatically by the camera or manually by the photographer.

To select a focusing point manually: Press the focusing point selector button on the top of the camera, and turn the Main Dial until the desired point is indicated on the viewfinder display and in the LCD panel. The light-metering and flash-exposure measurements are linked to the area covered by the selected focusing sensor.

To switch back to automatic focusing point selection: Press the focusing point selector button, and turn the Main Dial until all seven points are shown on the LCD display.

In any Creative Zone mode, the camera retains the last focusing point selected—even if the camera has been turned off and then on again. When an Image Zone mode is selected, however, the camera switches to automatic focusing point selection.

Autofocus Range

The operating range of the AF sensors built into the camera is between EV 1 and 18 at ISO 100. At the low end, this corresponds approximately to an exposure time of two seconds at f/1.4. Even under conditions of very low light, the Rebel 2000 is still capable of automatic focusing. In darkness or in a low-contrast situation, the built-in krypton AF assist beam will turn on to assist the autofocus system. This feature allows automatic focusing with most EF lenses from 35mm to 135mm and distances of 3.3 feet (1 m) to about 15 feet (5 m). With this system, autofocus is possible even in complete darkness.

When an accessory EOS-dedicated Speedlite or aftermarket flash unit (other than the Canon Speedlite 380EX, 540EZ, or 550EX) is mounted, the camera's krypton AF assist beam is used. If a 380EX, 540EZ, or 550EX is mounted, however, its own near-infrared AF assist beam takes over. This increases the AF range to about 30 feet (10 m) and cuts drain on the camera's batteries.

Autofocus Measurement and Motorized Lens Control

With all EOS Rebel models, distance measurement takes place within the camera, but the lens is adjusted by a motor housed inside the lens. Currently, Canon lenses use four types of drive motors: the ring-type USM (Ultrasonic Motor), Micro USM, AFD (Arc Form Drive), and a standard small electric motor. The advantage to mounting the motor within the lens is that the Canon camera can select the best motor to match the characteristics of each lens. The speed of the autofocus system also depends on the lens' motor drive. The Canon system allows the motor drive to be individually adjusted to move the components of each lens for optimum performance.

The fastest drives in the Canon line of lenses are the USMs. These high-end lenses, which use the ring-type USM, mainly include high-performance zoom lenses and telephotos to satisfy the most sophisticated professional demands. The original EOS lens motors—the AFD motors—are not used in any current EF lenses. A standard, small electric motor is used in only one lens, the 100mm macro. The advantages of individual drives are discussed in detail in the lenses chapter.

Manual Focus Mode

If the autofocus system can't focus due to the particular characteristics of the subject, the green autofocus LED in the viewfinder will blink. This situation may occur with:

❏ Subjects that are extremely low in contrast, strongly backlit, or monochromatic
❏ Subjects that have a very light surface
❏ Horizontal structures with a uniform surface
❏ Highly reflective objects
❏ Subjects at different distances within AF measuring field.

In these situations, you may need to use Manual focus (this is different from manually focusing when using an AF mode in the Creative Zone). To use Manual focus:

❏ Move the switch on the lens from AF to M—unless your lens is equipped with a USM (Ultrasonic Motor) or a Micro USM and a distance scale. These lenses can be focused manually at any time, so you don't have to switch to M.

❏ Turn the focus adjustment ring on the lens until the subject appears in sharp focus on the viewing screen. You can evaluate focus by looking at the viewing screen or by referring to the viewfinder's autofocus LED, which lights to confirm focus.

Manual focusing is necessary only in exceptional cases; even in these instances, you can usually use autofocus. To use autofocus, first focus on another subject that's the same distance from the camera as your main subject. Then, lock focus by maintaining light pressure on the shutter release button while you recompose the photo.

You may also want to use Manual focus to experiment with a variety of creative effects.

Note: Some early Canon EF lenses (those with no distance scale) do not offer manual focus capability.

Metering

A properly exposed photo is one in which precisely the right amount of light has reached the film to produce an image that corresponds either to the actual scene or to the photographer's vision of that scene. This principle applies to authentic color reproduction as well as to correctly perceived tonal differences in black-and-white photos. Thanks to the EOS Rebel series' well-conceived exposure control system, correctly exposed pictures are not hard to produce.

For a camera to produce correct exposures, light intensity must be measured. To this day, there is no integrated light meter that will produce a perfect metering result in every situation. Because different subject details reflect light in different amounts, an exposure meter detects the sum of all brightness readings and comes up with an average brightness value. Conventionally, exposure settings are based on the assumption that the average brightness of a scene should be approximately 13%-18% reflectance (neutral gray). Today's light metering systems in the Canon EOS models have been greatly improved with the addition of microprocessors and special sensors, giving the system greater flexibility and accuracy.

The Canon EOS Rebel 2000 features three exposure metering systems and two flash metering systems (see Flash chapter for a detailed discussion of these systems).

Exposure
❏ 35-zone, autofocus-based evaluative metering, active in all exposure modes except Manual.
❏ Partial metering with spot autofocus, activated by pressing the partial metering button; available in Creative Zone modes.
❏ Center-weighted average metering, activated automatically in Manual mode.

Flash
❏ 35-zone evaluative through-the-lens (E-TTL) flash metering, linked to the seven focusing points (sensors) and using the Canon Speedlite 550EX, 380EX, or 220EX flash unit.

❏ Canon's exclusive advanced through-the-lens (A-TTL) flash metering, with Canon Speedlite 300EZ, 420EZ, 430EZ, or 540EZ flash unit.

35-Zone Evaluative Metering

The Canon Rebel's 35-zone evaluative (or multi-zone) metering system is the simplest and most reliable method of metering for any situation. The camera uses 35-zone evaluative metering automatically in every exposure mode except Manual. (Other Rebel-series cameras have three-zone and six-zone metering.) Even in situations that are difficult to meter, the EOS Rebel 2000's metering system provides the most appropriate exposure values.

In determining exposure, each zone is measured individually. The camera's microprocessor assumes that the subject is covered by the active focusing point (the one selected manually by the photographer or automatically by the camera). Canon's AIM system gives the lighting in this area the greatest consideration. The camera then calculates correct exposure by comparing the brightness surrounding the active focusing point to the brightness of the rest of the scene. In this way, the camera's exposure metering is always related to the most important part of the image, and that is generally where the point of focus is. As a result, the area surrounding the active AF sensor is of particular importance.

Note: With this metering system, after autofocus has been achieved, exposure values are locked as long as the shutter release button is pressed partway down. Meter readings cannot be locked if the lens is set to Manual focus.

The evaluative metering system has two main advantages over the partial and center-weighted average metering systems: Exposure measurement is weighted on the active focusing point, rather than being locked on the center of the picture area; and evaluative metering is the only system that can automatically apply exposure compensation based on its analysis of the scene.

Photographers who work with color negative films can trust the evaluative metering system completely. A poor exposure made on color negative film can be adjusted somewhat in the

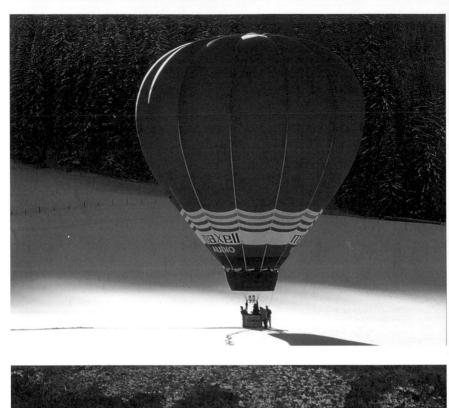

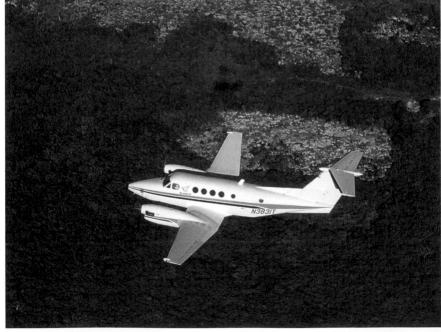

print-making process, but slide films lack this step, so exposure is more critical. Because of slide film's limited exposure latitude, those who use slide films might sometimes want to change the exposure values suggested by the camera. Slide films can take only a small amount of under- or overexposure and still produce photos with sufficient detail and color gradation.

Partial (Spot) Metering

Although technically an image may be "correctly" exposed, the exposure may still not be ideal. Sometimes evaluative metering, which is programmed to compensate for certain situations, still does not produce the desired effect. This is where partial (spot) metering can be useful.

Partial metering is often employed in creative image composition, and can be used in any Creative Zone mode. This metering system allows you to interpret the lighting situation to achieve a specific mood or intention, interpreting or enhancing an existing mood. Partial metering is particularly appropriate when the brightness differences in a scene may lead to over- or underexposure of important image details. For example, to correctly expose a detail in a high-contrast area, you must deliberately sacrifice normal contrast in the rest of the picture through over- or underexposure. Because of the difficult choices you must make, this metering method requires some practice to master.

The measuring field for partial metering on the Rebel-series cameras is defined by the focusing point in the center of the viewfinder. The metering area is only 9.5% of the entire image area.

Partial metering can be activated in any Creative Zone mode. To activate partial metering, press the partial metering button (marked with a star on the back of the camera). A star symbol then lights in the viewfinder.

◁ **The multi-field metering system of the EOS Rebel 2000 provides correct exposure in a variety of difficult lighting situations.**

Each partial metering reading is stored for as long as the shutter release button remains lightly pressed, for four seconds after pressure has been removed from the shutter release button, or until the picture has been taken, whichever comes first. The four-second delay allows you to adjust other camera controls, such as exposure compensation, before shooting. With this system (unlike with evaluative metering), exposure readings can be stored with the lens set to manual focus or autofocus.

An Example of Partial Metering

Let's say you want to shoot a portrait at sunset, and the red sun is just starting to dip behind the mountains in the background. You could use the camera's Portrait mode, but the aperture would open very wide. Due to the shallow depth of field produced with a wide aperture, the sun would be out of focus.

An alternative would be to illuminate the person with flash to reduce the extreme range of contrast in the image. For snapshots, this is certainly a satisfactory solution, but might not produce the desired effect.

How you choose to partially meter the scene can drastically affect the result. If the partial metering area is aimed directly at the sun, the camera will meter the brightness of the sun at medium reflectance and recommend a fast shutter speed. The subject in the foreground will be underexposed and appear as a silhouette in the photo. This technical manipulation guarantees a mood-charged image. To soften the severity of the silhouetted subject, a touch of flash will provide detail in the shadow areas.

Quite a different mood is attained when you point the partial metering field at the darkest area of the image—in this example, the subject's face. The face will be exposed correctly, while the pastel colors of the sky and sun are overexposed and therefore less intense. In this way, a very romantic picture is created, although without the drama of the sunset.

The trick in most cases is to provide a touch of detail in either the lightest or the darkest area of the picture. Between these two extreme situations lie a great number of combinations and brightness levels that can be achieved by an experienced photographer using partial metering. Those who want to use their Rebel camera to compose pictures creatively should first take pictures using 35-zone evaluative metering and then experiment with partial metering.

Center-Weighted Average Metering

Center-weighted average metering is available only in Manual mode. In this mode, the Rebel 2000's metering system is set automatically to center-weighted metering unless you manually select partial metering. With the center-weighted metering pattern, the entire image area is measured, and then averaged for the entire scene; greater emphasis is thus given to the center. Because center-weighted average metering does not automatically apply exposure compensation (as the evaluative metering system does), you retain complete control over exposure, as is usually desired in Manual mode.

Choosing an Exposure Mode

Every Rebel-series camera offers the photographer a wide selection of exposure modes to accommodate just about any shooting situation and level of expertise. These range from fully automatic subject-specific modes to modes that give the photographer various degrees of control over the exposure. All that is required is a turn of the Rebel 2000's Command Dial.

The Command Dial features 11 exposure modes from which to choose; the setting determines the complexity of techniques required of the photographer. The six Image Zone modes are Full Auto (Green Zone), Portrait, Landscape, Close-Up (macro), Sports, and Night Scene, all designed to make picture-taking as easy as possible. The five Creative Zone modes—Program (P) Autoexposure (AE), Shutter-Priority (Tv), Aperture-Priority (Av), Automatic Depth-of-Field (A-DEP), and Manual modes—offer the photographer greater flexibility in customizing the exposure settings.

Features Available in EOS Rebel 2000 (EOS 300)

Command Dial Mode	Autofocus		Focusing Point Selection		Film Advance		Metering Mode			Flash	
	One-Shot AF	AI Servo AF	Auto	Manual	Single	Continuous	Evaluative	Center-weighted averaged	Partial	Automatic Firing	Manual
□		●	●		●		●			●	
🙎	●		●			●	●			●	
🏔	●		●		●		●				—
🌷	●		●		●		●			●	
🏃		●	●			●	●				—
🌃	●		●		●		●			●	
P		●	○	○		●	●		(●)*		●
Tv		●	○	○		●	●		(●)*		●
Av		●	○	○		●	●		(●)*		●
M		●	○	○		●		●	(●)*		●
A-DEP	●		●			●	●		(●)*		●

● Set automatically. ○ User-selectable. * Available only while partial metering button is pressed.

The EOS Rebel 2000's exposure modes each offer the photographer a specific combination of focusing, film advance, metering, and flash options.

Image Zone Modes

The six Image Zone modes on the Rebel 2000 make it easy to photograph typical subjects (Rebel-series models prior to the Rebel G have only five modes, lacking Night Scene mode). By using the five subject-specific modes in the Image Zone (Full Auto mode is not subject specific), photographers who are not necessarily well versed or interested in photographic principles can experiment creatively, while leaving the technical problem-solving to the camera. To make the most of these programs, however, photographers will benefit from having a basic knowledge of how and why they work.

Programmed Image Control (PIC)

The Image Zone modes on the Rebel 2000 are governed by what Canon calls PIC (Programmed Image Control). These modes, which control all important camera functions automatically, are ideal for photographers who want to get optimal results but don't want to be overwhelmed with photographic principles.

The PIC options (which are the same as the modes) are: Full Auto (Green Zone), Portrait, Landscape, Close-Up (macro), Sports, and Night Scene. Readily recognized pictograms on the Command Dial make selecting one of the five subject-specific modes—again, Full Auto is not subject specific—easy. After you choose an appropriate mode, you need only to compose the image and take the picture. The PIC system automatically selects the focus, exposure metering system, and film transport option to fit the subject.

In low light, for example, if the selected shutter speed is too slow for a hand-held exposure in Landscape or Sports mode, the shutter speed will blink in the viewfinder display and LCD panel to warn you of the risk of camera shake. In all other PIC modes, if the light level dictates a slow shutter speed, the built-in flash pops up automatically and no blinking alert occurs. (If a Speedlite flash unit is attached but is not turned on, the shutter speed will blink.)

Full Auto (Green Zone) Mode

The green rectangle on the Command Dial of all EOS Rebel series cameras—the Rebel series' standard, fully automatic mode—has

Complex lighting situations like this are no problem for the Rebel 2000's Full Auto mode. Photo by Bob Shell.

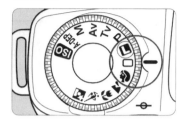
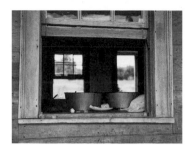

exactly the same purpose as a green traffic light signaling the driver that it's OK to go.

Canon describes Full Auto mode as an "intelligent automatic program." Its intelligence lies in how it uses the full range of the camera's features without requiring user input. Full Auto accomplishes this by analyzing information that is passed from the lens or flash unit to the camera's central microprocessor. Using such analysis, the camera maximizes the range of possible hand-held exposure settings based on the focal length of the lens in use. It is even able to identify intermediate focal lengths when zoom lenses are used.

In Full Auto, the camera determines the best combination of shutter speed and aperture for a given picture. The LCD panel displays the selected shutter speed, aperture, and, as in all other PIC modes, the frame number and battery status.

In addition, in Full Auto mode the built-in flash pops up automatically in low-light or backlit situations, the focusing point is selected automatically by the camera, and the Rebel 2000's AIM system is used, linking evaluative and flash metering to the main subject, as determined by the AF system.

Note: If the scene's brightness level is beyond the range of the film, the minimum or maximum shutter speed and aperture settings will blink in the LCD panel and viewfinder display to warn of the potential of poor exposure. The camera will fire, even though over- or underexposure will probably occur. To remedy this, use a slower or faster film, or add a circular polarizer or neutral-density filter.

Also in Full Auto mode, auto-switching autofocus (AI Focus) is activated and the film transport operates in single-frame advance (the shutter release must be pressed once for every exposure).

In AI Focus mode, the camera uses One-Shot AF until the subject starts to move; at this point, the camera switches to AI Servo AF automatically. The shutter will fire only after focus has been achieved and the flash (if in use) has signaled its readiness. A green flash symbol in the viewfinder blinks in extreme backlighting or low-light conditions. At almost the same instant, the Rebel 2000's built-in flash unit is automatically activated. The 35-zone evaluative metering system assures more accurate exposure even in extreme lighting situations, such as sunlit snowscapes.

Technically, Full Auto mode is identical to Program (P) mode, in the Creative Zone. Unlike P mode, however, Full Auto offers no overrides or adjustments (such as Program Shift), the flash pops up automatically in low light, and only evaluative metering is possible. It does not matter what focal length is used in this mode; any Canon EF lens can be used.

Full Auto mode is the best selection for snapshots and general picture-taking. It's also great for quickly grabbing a shot if an interesting subject appears unexpectedly and there's no time to think about setting the camera controls. If you're in doubt on what program to use, Full Auto mode will give you the highest percentage of successful pictures.

Portrait Mode

Portrait mode is ideal for creating photos with a clearly focused subject surrounded by a blurred background. This mode is programmed to set the lens' widest aperture to produce a picture that has a highly selective area in focus, dissolving even the most distracting or annoying background to a pleasant blur—an effect usually desirable in most portrait photographs and best achieved if the subject is far away from the background. Portrait mode uses the 35-zone evaluative metering system and One-Shot AF. Continuous film advance is possible by fully depressing and holding the shutter release, letting you capture subtle changes in the subject's expression. The Rebel 2000's pop-up flash is activated automatically in backlit or low-light situations.

Portrait mode is designed especially for use with telephoto lenses. When using zoom lenses, a longer focal length is recom-

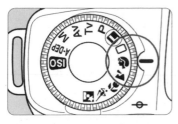

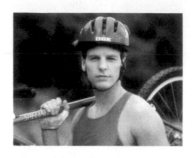

Portrait mode is perfect for taking head-and-shoulders shots such as this.

mended. Getting the eyes in focus is of utmost importance in a portrait. When taking portraits, fill the frame with the subject's head and shoulders, and direct the active autofocus point at the subject's eyes. If composition limitations do not allow the active focusing point to correspond with the subject's eyes, aim it at the eyes, press the shutter release lightly to lock focus, adjust the framing, and then depress the shutter release fully to take the picture.

Landscape Mode
Landscape mode is programmed with One-Shot AF and single-frame film advance. After all, taking pictures of landscapes is rarely a fast-paced endeavor! Landscape mode reduces the exposure by closing the aperture and increasing the shutter speed in equal increments once an aperture of f/5.6 and the reciprocal value of the focal length are reached. Natural landscapes and seascapes are not the only subjects you can use this mode for; buildings and cityscapes can also be captured very successfully as well. For excellent overall exposure, 36-zone evaluative metering is used.

In developing the Landscape mode, Canon took many factors into consideration. An analysis of thousands of landscape pictures showed that nature scenes are usually taken at the infinity or near-infinity distance range. Landscapes shot by amateur photographers are almost exclusively panoramic views. When there is a lot of information to be included in a scene, it is expected to be in focus from front to back; Landscape mode, therefore, sets a small aperture to achieve an extended depth-of-field range. Extreme, super-wide-angle lenses and zoom lenses

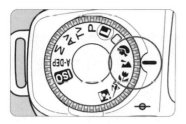

For subjects such as this, use Landscape mode.

with a minimum focal length of between 28mm and 50mm are highly suitable in this mode; telephoto focal lengths greater than 200mm are not recommended.

If you use Landscape mode for scenes that meet the above criteria, more than 90% of your landscapes will be correctly exposed and exhibit impressive spatial sharpness. If, however, you like to pose people in the foreground of a picture, such as placing members of your family in front of the Grand Canyon, Niagara Falls, or the Eiffel Tower, you should switch to the A-DEP mode with the Rebel 2000 or to DEP mode with earlier Rebel models (see page 15). These modes will help to ensure that both the people and the background are sharp.

Close-Up (Macro) Mode

Close-Up (macro) mode is specifically programmed for shooting with extreme magnification, using 35-zone evaluative metering to achieve optimal exposure of every detail. This mode uses One-Shot AF and single-frame film advance, as close-up work usually involves a relatively stationary object and often requires careful planning for every frame.

Close-Up mode operates in Aperture-Priority (Av) mode with a maximum aperture of f/4.0 when focal lengths of less than 80mm are used, and a maximum aperture of f/5.6 when focal lengths of 80mm or greater are used. The built-in flash pops up automatically if ambient light is insufficient to achieve good exposure. When the ambient light is adequate for good exposure without flash, Close-Up mode gives preference to smaller apertures so that depth of field will be as great as possible, while setting a

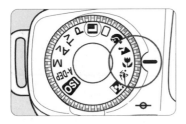

Details of flowers are easy to capture using Close-Up mode.

shutter speed fast enough for hand-held shots. In this way, Close-Up mode operates the same as Landscape mode, which also uses a maximum aperture of f/5.6.

But in Close-Up mode, the photographer reaches the limits of sufficient existing light very quickly. This is why the mode is designed for shots taken in existing light as well as with flash, which will be activated automatically (when necessary) with Rebel models with built-in flash. If the subject is backlit, the flash will function as fill. It becomes the main light, however, if there is not enough ambient light for proper exposure.

A Canon Speedlite flash unit can be slipped into the camera's hot shoe for additional lighting. When this is done in Close-Up mode (and in any other PIC mode), though, the exposure values revert to those appropriate for Full Auto mode—which may not meet the photographer's intentions. If you experience problems from the limited photographic range produced when using Close-Up mode, you might try one of the Creative Zone modes, which can give you more control over exposure settings.

Sports Mode
Sports mode is ideal for taking sharp pictures of fast-moving action or candid photos of everyday activity without recording motion blur. It is particularly suited to focal lengths of 135mm and longer and zoom lenses with a minimum focal length of 70mm, such as Canon's EF 70-200mm lens. This program gives preference to fast shutter speeds to produce super-sharp pictures of any normal activity. Whether you are shooting a playful pet, a holiday gathering, or family vacation, it's the ideal program for taking snapshots.

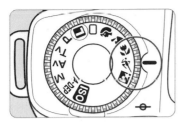

Sports mode is great for shots of moving subjects.

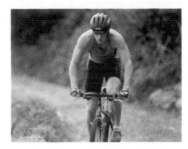

It is also possible to obtain sharp photographs of sporting events using this mode (the emphasis is on the word "possible"!). Anyone going to an auto race without first taking a few practice shots in Sports mode should not be surprised to achieve only limited photographic success. It is just not possible to pull out a camera at the last moment, press the shutter release button, and obtain a complete roll of spectacularly focused pictures. You need to build up experience in predicting the exciting moments of the sport being photographed and move up close—ideally with focal lengths longer than 300mm. Only then will the Sports mode reduce your shooting technique to simply pressing the shutter release button.

In Sports mode, movements are meant to be frozen and reproduced in sharp focus. Priority is given to a fast shutter speed—not necessarily achieved by setting the largest possible aperture, which would produce extremely shallow depth of field. To help improve depth of field while still setting a relatively fast shutter speed, Sports mode operates at maximum aperture plus 3/4 stop until the light is bright enough to allow correct exposure at a shutter speed of, at most, 1/focal length. As the light level increases, the program selects progressively faster shutter speeds to stop action, while reducing the aperture size to improve depth of field as well. As a result, Sports mode can shoot a high-speed 200mm f/1.8 lens between 1/200 second and 1/600 second. The program will begin to reduce the aperture only when the maximum hand-held shutter speed has been reached. This type of exposure control is particularly useful in the telephoto range over 200mm.

Sports mode uses continuous film advance and AI Servo AF. By beginning to shoot an action series before the subject is framed exactly as you wish, you allow the autofocus system to recognize and track the approaching movement. The camera will then compute with extreme precision the location of the subject at the time the picture, and the next measurements are taken. Every photo in a series of even fast-moving subjects will be in focus, from first to last. Practice, however, is required.

To practice photographing moving subjects in Sports mode, begin by tracking the subject with the central focusing point. (Press the shutter release halfway down to lock on the subject, and start tracking; the camera may not be able to focus the subject accurately unless you follow this step.) The shutter will not release until the camera has found a readable subject. Once the camera starts tracking the subject in the center of the frame, you're free to start shooting by pressing the shutter release button all the way down. The Rebel 2000's predictive AF system will track the subject not only toward or away from the camera, but also to the left or right, as long as the subject remains within any of the seven AF focusing sensors. The maximum shooting rate while tracking focus is one frame per second.

Night Scene Mode

When set for Night Scene mode, the Rebel 2000 will automatically use a slow shutter speed to capture nighttime or low-light images and will combine this with foreground exposure from the built-in flash. This mode can also be used with the Canon Speedlite 220EX flash unit (introduced along with the Rebel 2000) or other EOS

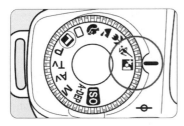

Night Scene mode lets you illuminate the subject while also giving the background good exposure.

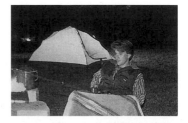

Speedlite flash units. Night Scene mode operates in One-Shot AF, single-frame advance, and 35-zone evaluative metering.

Night Scene mode is useful for photographing people against sunsets or against lighted tourist attractions at night. Because the main exposure for the background requires a very slow shutter speed, this mode is best used with the camera on a tripod or other solid support, and the subjects in the foreground must remain reasonably still during the exposure. If the subjects move and there are lights in the background, they may appear in the final photo as "ghosts," with the background light showing through them.

Creative Zone Modes

The Rebel-series cameras feature five exposure modes in the Creative Zone of the Command Dial. These modes are intended for advanced photographers who are familiar with the parameters required for a successful shot, the selection of a specific shutter speed, aperture, or metering pattern, and when to use the built-in flash, if desired. All Creative Zone modes use AI Servo Focus, with the exception of A-DEP mode, which uses One-Shot AF.

With these modes, technical information pertinent to the selected mode appears on the LCD panel and viewfinder display. All autoexposure modes warn of overexposure or underexposure—the shutter speed or aperture, or both, will blink. In Manual mode, the exposure level scales in the viewfinder and LCD panel indicate whether the exposure settings you have chosen will result in an over- or underexposed image, according to the camera's readings.

P Program (P) Autoexposure (AE) mode (fully automatic; no shooting techniques required)—The camera selects both shutter speed and aperture settings for proper exposure; these settings can be modified by using the Program Shift function. Flash use is elective, not automatic (unlike Full Auto mode).

Tv Shutter-Priority (Time value) AE mode—The photographer selects the shutter speed, and the camera selects the appropriate aperture for correct exposure.

Page 57
Above: Shutter-Priority AE mode is great for waterfront shots. Using a fast shutter speed freezes the action of the waves and the ships passing by.

Below: Full Auto mode is able to produce an excellent exposure of scenes that have a wide range of highlights and shadow tones.

Page 58
Above: The exaggerated perspective in the top photo is achieved by using a wide-angle zoom, which emphasizes the lines of the train.

Below: Photos such as this, with extreme highlights and shadows, are best taken using Full Auto or Program mode. The evaluative metering system automatically assesses the scene and selects the appropriate exposure.

Page 59
Above: Often, ultra-wide-angle lenses are used to capture expansive scenes such as this. The exaggerated perspective allowed by such lenses adds dynamic visual interest.

Below: Taking photos at night is easy with any Rebel camera. Use Aperture-Priority AE mode and let the camera select the shutter speed, or use Manual mode in the Bulb setting for time exposures. Always use a tripod when shooting at night.

Page 60
The built-in flash operates automatically in Full Auto mode. It adds sparkle to the highlights in images such as these and keeps detail in the shadows from being lost.

59

63

Page 61
For travel photographs, the very fast 28-70mm f/2.8 L USM lens could be the ideal choice. It has a versatile zoom range, its wide aperture allows you to photograph in dim light, and its image quality is extremely sharp.

Page 62
Above: To render the main subject in sharp focus and blur the background so it will not be distracting, use Aperture-Priority AE mode and set a large aperture.

Below: In this photo, the photographer selected a smaller aperture to bring more of the background into focus. The difference in color helps to differentiate the foreground from the background.

Page 63
Canon's 20-35mm f/3.5-4.5 USM lens is excellent for taking scenics. Its 35mm focal length is ideal for photos such as the upper one, while at 20mm it can capture the wider view, below.

Page 64
Often, a subject can be framed successfully in several ways. A telephoto zoom makes it easy to experiment.

Av Aperture-Priority (Aperture value) AE mode—The photographer selects the aperture, and the camera selects the appropriate shutter speed for correct exposure.

A-DEP Automatic Depth-of-Field mode (Rebel X, XS, G [EOS 500 series], and 2000 [300 series])—The range of apparent focus is defined by the subjects that fall within the camera's seven focusing sensors; shutter speed and aperture are set automatically by the camera to produce sufficient depth of field to encompass those subjects.

M Manual mode—The photographer selects the shutter speed and aperture. These parameters can be selected freely or based on the camera's exposure meter readings.

Program (P) AE Mode

Program (P) AE mode is different from Full Auto (Green Zone) mode in three ways: it allows Program Shift (see description below); flash use is not automatic in low light; and partial metering can be selected. In P mode, the aperture and shutter speed are selected by the camera. To achieve this, the camera's

exposure control considers the focal length of the diaphragm. This diaphragm makes it almost impossible to make an incorrect exposure. Should the risk of bad exposure occur, however, shutter speed and aperture data will blink in the viewfinder. If this does happen, and there is too much light (for example, when using super-high-speed films in sunshine), a neutral-density (ND) filter can be helpful. If there is not enough light, you can use flash.

Rebel series cameras do not warn of camera shake in P mode because Canon engineers assume that anyone choosing the Creative Zone modes will be aware of this potentiality. The same is true of the flash warning. Flash use is entirely elective in all Creative Zone modes. Once you press the flash button, the built-in flash pops up and the shortest possible shutter speed for flash, 1/90 second, is automatically set.

In normal lighting situations, P mode is a convenient alternative, even for advanced photographers—they can simply adapt the mode's exposure settings as desired or required, one shot at a time. This is called "program shifting." By turning the Main Dial while the shutter release is pressed partway down, you can change the shutter speed and aperture without taking your eye off the subject. The exposure information is displayed in the viewfinder, and the adjusted values are immediately visible.

With a simple turn of the Main Dial, all available aperture values and corresponding shutter speeds can be adjusted based on measured light conditions. Though the actual exposure remains the same, the combination of shutter speed and aperture is shifted to arrive at an equivalent exposure to produce a certain effect. For example, when the brightness corresponds to an exposure value of 13 with a standard 50mm lens, the following combinations of apertures and shutter speeds are possible (stepless intermediate values are not listed): f/2 and 1/2000 second; f/2.8 and 1/1000 second; f/4 and 1/500 second; f/5.6 and 1/250 second; f/8 and 1/125 second, and so on, up to f/22 and 1/15 second. With the touch of your finger—without changing exposure, deactivating the automatic features, or taking the camera away from your eye—you can shift to a faster shutter speed for moving objects or to a wider aperture for a particularly large depth of field. Once a value has been set, it is stored for four seconds.

When using zoom lenses, shift the settings only after the focal

length has been adjusted, because the aperture value will change with a change in focal length. Don't be surprised if in one situation the minimum aperture possible is f/22 and then at another time an aperture of f/27 is selected with the same lens. This range reflects that the zoom lens in use has a variable effective maximum aperture, which means that the effective minimum aperture also varies with a change in focal length.

Shutter-Priority AE (Tv) Mode
By setting the Command Dial to Tv (Time Value or Shutter-Priority AE mode), you can select a shutter speed between 30 seconds and 1/2000 second in 1/2-stop increments. After you have selected the shutter speed, the camera automatically sets the appropriate aperture. If the aperture indicated in the LCD is constantly illuminated, the aperture defined by 35-zone evaluative metering has been set. If, however, the largest aperture value blinks, this means the photo will be underexposed. In this case, set the shutter speed to slower speeds by turning the Main Dial until the blinking stops. If the smallest aperture value is blinking, this indicates overexposure. To correct the exposure, increase the shutter speed by turning the dial until the blinking stops. Although evaluative metering is this mode's standard pattern, you can also select partial metering.

Shutter-Priority mode is used mainly when the photographer requires a specific shutter speed for artistic reasons; there is no camera-shake warning. In this mode, the aperture acts exclusively to control the amount of light, and its creative effectiveness is disregarded in favor of the required shutter speed. Generally, fast shutter speeds are used to stop motion. Such shutter speeds (1/250 and up) should be selected when pictures are taken from a moving vehicle, when sports or action shots of fast-moving subjects are taken, or when the final print is to be enlarged. But the reverse is also possible with Shutter-Priority mode—slow shutter speeds (about 1/30 second and slower) can be used to produce creative motion-blur effects. Just remember to mount the camera on a tripod. Selecting longer shutter speeds from one to several seconds is suitable even for architectural shots. Everything stationary will be sharp, but anything that moves during the exposure (vehicles or people) will be blurred. Extremely long exposure times make objects that move through the picture completely

invisible. This is a favorite technique for making busy, high-traffic areas appear deserted.

Aperture-Priority AE (Av) Mode

In Aperture-Priority AE mode, the photographer selects the aperture value (or Av) by turning the Main Dial. In this mode, the exposure can be determined either by 35-zone evaluative or by partial metering. To achieve proper exposure, the exposure control system automatically selects the required shutter speed based on the existing amount of light and aperture setting.

Av is the best mode to use whenever depth of field is important to the image. It may be that only shallow depth of field is desired (for example, sacrificing the sharpness of the background in a portrait shot). On the other hand, it is sometimes desirable to create an image that is sharp from front to back to produce particularly effective shots of landscapes or buildings when the overall environment is important. The Rebel 2000 series is capable of capturing these types of scenes better, more easily, and even more clearly with its A-DEP mode (see below).

In Av mode, incorrect exposures can happen. Impending poor exposures are indicated by a blinking aperture value. Underexposure occurs only when a camera-selected shutter speed of 30 seconds is not long enough; overexposure occurs when 1/2000 is not fast enough. In both cases, the aperture selection can be adjusted by turning the Main Dial.

Automatic Depth-of-Field (A-DEP) Mode

Photographic subjects are usually three-dimensional, but are recorded on the film in two dimensions, with only a single plane of sharp focus. Any subject falling on this plane is reproduced in sharp focus. Objects located in front of or behind the plane do not come into sharp focus on the film.

When a print or projected image is viewed, there is an area in front of and behind the plane of sharp focus that is perceived to be in focus. This range of apparent sharpness—generally distributed 1/3 in front of the plane of focus and 2/3 behind the plane of focus—is referred to as "depth of field." One of the factors affecting depth of field is lens aperture. Generally, depth of field is shallower with large apertures and greater with small apertures.

The depth of field at a given aperture can be calculated and is

listed in depth-of-field tables available for every focal length. A-DEP mode on the Rebel 2000 eliminates the need to study tables while shooting, allowing you to record, in sharp focus, objects located at different distances from the camera. To accomplish this, the camera's seven AF sensors measure the distance of nearest and farthest objects from the camera, and the camera automatically selects an aperture that assures everything within such range will be in apparent sharp focus. You just point the camera at the main subject and press the shutter release partway down. The camera computes the appropriate aperture that will produce the required depth of field.

Should the aperture selected not be adequate to produce a sharp image of the objects in the scene, the lens' smallest aperture value will blink on the display. If you still want that photograph, a correct exposure will be taken with the smallest possible aperture, based on the metering sensors' readings. If you have time for additional attempts, however, the image's focal range or reproduction ratio should be reduced. To achieve this, move farther back or stay in the same place and switch to a shorter focal length.

When the smallest aperture display blinks in the viewfinder, at least one correct exposure setting is possible; when both the shutter speed and aperture displays blink, a poor exposure will occur. If there is inadequate light, flash can be used. If that is done, however, the camera will automatically switch out of A-DEP mode and operate in Program mode, and you must make sure that all subjects fall within the range of the flash unit.

In low-light situations, if the built-in flash unit is folded down or if the camera doesn't feature a built-in flash, the camera may select a long exposure to produce great depth of field, despite the risk of camera shake. A tripod is recommended in such situations. For information on how to operate the slightly different DEP mode in other Rebel models, see page 15.

Manual (M) Mode
The use of Manual mode assumes that the photographer wants full control over exposure settings. The camera therefore selects center-weighted average metering to prevent the evaluative metering system from applying exposure compensation on its own (as it is apt to do).

When it's important to render elements in the foreground and background in sharp focus, use A-DEP mode or Aperture-Priority mode and set a small aperture for extensive depth of field.

You adjust the shutter speed by turning the Main Dial, and select the aperture by pressing the Av +/– button while turning the Main Dial. If you follow the same procedure every time you use M mode, adjustments can be made smoothly and surprisingly fast. Once you have selected the shutter speed and aperture, they are both displayed in the viewfinder and LCD panel. Any deviation between the exposure values you have chosen and those the camera determines to be "correct" is displayed on a scale in the viewfinder and LCD panel in 1/2-stop increments, up to +/–2 stops. This can be useful information in fine-tuning your exposure. To match the camera's exposure settings, set the aperture and/or shutter speed until the moving marker under the exposure level scale is under the central large bar on the scale.

In Manual mode, the camera will not warn you of potential camera shake, so be sure to set your shutter speed accordingly if a tripod is not being used.

Indicates a correct exposure	**-2.1.Ⓞ.1.2⁺** ■
Indicates overexposure	**-2.1.Ⓞ.1.2⁺** ■
Indicates underexposure	**-2.1.Ⓞ.1.2⁺** ■

When the camera is in Manual mode, this scale will light in the viewfinder and LCD panel, indicating how the exposure values you have set compare to those recommended by the computer.

As noted earlier, metering in this mode is center weighted; you can elect, however, to use partial metering if desired. Center-weighted average metering helps even out differences in brightness in shots with similar illumination, making it particularly beneficial when you are shooting a series or when pictures are intended for presentations using lap-dissolve techniques.

When shooting many photos of a subject using different focal lengths, partial metering is recommended. Experienced photographers use this method even with telephoto lenses to get pinpoint-accurate metering results. Partial metering, however, is successful only when the correct point is metered; otherwise, the risk of poor exposure is considerably greater than with other metering methods. In critical situations, it is best to use a KODAK Gray Card as the optimal metering guide. Generally, all exposure meters, including those in the Canon Rebel series, are calibrated to this card's reflectance.

On televised sports broadcasts, distinct changes in image brightness are always noticeable when a switch from a wide-angle setting to a super-telephoto setting takes place. The image becomes lighter when the details are in the shadows, and darker with full illumination. The same phenomenon happens in still photography, because normally greater brightness differences must be dealt with in the wide-angle range, rather than when details are shot with a telephoto lens. This will become obvious when the focal length of a zoom lens is changed. Partial metering will determine metering differences at the shortest and longest focal lengths, even when the exposure is correct for both situations. Such differences can be prevented by a single metering operation and subsequent manual adjustment.

Partial metering is suitable in all problematic lighting situations that might strain even the evaluative metering system, especially

if artistic effects under critical lighting conditions are desired. After all, only the photographer knows which detail should be emphasized by special lighting, and not even the most sophisticated automatic exposure program can make such decisions. This principle applies in particular to lighting situations with excessive differences in brightness between the main subject and the background, such as stage sets or backlit subjects. In these instances, the photographer must determine the most appropriate exposure. A portrait of a girl at sunset or a backlit windmill (with direct incident light) can be rendered with a number of different exposures, and all will be satisfactory. The final choice is based on the mood desired in the final photograph.

Bulb (Time) Exposure

As mentioned before, the Rebel-series cameras offer a large range of automatically and manually controlled shutter speed settings. With all Rebel cameras, this range can be expanded in Manual mode by using the Bulb setting. To achieve this, turn the Control Dial to M and turn the Main Dial until the word "Bulb" appears on the LCD panel. At this setting, the shutter remains open as long as the shutter release is pressed. When shooting in Bulb, there is no warning of potentially poor exposure.

These shots require a tripod, and with the Rebel 2000 the Remote Switch RS-60E3 (see the accessories chapter) is recommended to prevent camera shake. With the camera set on Bulb, the remote release is pressed once to release the shutter, which has a sliding-lock feature that allows it to be held open indefinitely for time exposures.

Autoexposure Bracketing

The EOS Rebel 2000 is the second Rebel model to offer autoexposure bracketing (AEB). This feature, introduced on the Rebel G and available only in the Creative Zone modes, is useful when you are unsure whether you will be able to get the ideal exposure even with the camera's advanced metering capabilities. The AEB sets the camera to take, automatically, three photographs

You can take nighttime photos like this with the Rebel 2000. But don't use Night Scene mode; the flash isn't strong enough to light up the whole city! Use Manual mode and set the shutter speed to Bulb; to prevent camera shake, use a remote cable release and a tripod. Photo by Bob Shell.

individually or continuously; one is taken at the exposure settings chosen by the camera's metering system, one is underexposed, and one is overexposed. (When the self-timer is used, the three exposures will be taken continuously after the countdown is complete.) You can set the difference between the exposures in 1/2-stop increments up to +/–2 full stops. To set AEB, press the function button until the arrow lights next to the AEB symbol (three rectangles). Then turn the Main Dial to set the degree of bracketing, which will be displayed on the LCD panel. Bracketing can be valuable insurance in capturing a good exposure, especially if the lighting is unusual. To cancel AEB, set the bracketing amount to 0 or turn the Command Dial to an Image Zone (PIC) mode.

Multiple Exposures

Multiple exposures can be made in any of the Creative Zone modes, but not in the Image Zone (PIC) modes. To set the number of multiple exposures you want to make, press the function button until the arrow next to the multiple-exposure symbol (two overlapping rectangles) lights on the LCD panel. Select the number of exposures to be recorded on the frame by turning the Main Dial; the number of multiple exposures selected will appear on the LCD panel. The numbers count down on the LCD panel as each exposure is made. Any number from 2 to 9 can be selected; it is also possible to make any number of multiple exposures by resetting the number before taking the last photo in the sequence.

There are always questions about how to correctly expose multiple exposures. The number of exposures on a frame is not as important as how often picture elements will overlap. The most basic multiple-exposure shot involves shooting two images on one frame. If the subjects are in front of a dark background and do not overlap, they can be exposed on one frame of film without requiring any exposure adjustment. Accurate exposure in this situation is most easily achieved by using partial metering to prevent the background from affecting the meter reading.

When picture elements do overlap, they will be overexposed unless the exposure setting is adjusted. To achieve proper exposure, you need to dial in some minus compensation to underexpose each image slightly; the sum of all exposures should approximately equal that of a single exposure where elements overlap. A rough guide is –1 exposure value (EV) for two exposures, –1.5 EV for three, and –2 EV for four. (Reducing the exposure by one EV means that either the aperture or shutter speed is reduced by one stop.) But this is only a starting point, because subject reflectance and background illumination largely determine the final result. It's best to learn for yourself by doing a few experiments.

Appropriate exposure corrections can be made manually in any Rebel series camera. To do so in P, Tv, Av, and A-DEP modes, press the Av +/– button and set the correction factor by turning the Main Dial. The compensation factor is displayed on the LCD panel and viewfinder display. In Manual mode, make corrections by adjusting the aperture or shutter speed.

After shooting the number of set exposures, the multiple exposure function will deactivate automatically, the film will advance to the next frame, and the number of frames remaining in the roll appears in the LCD. Remember that if you set an exposure compensation value, you must reset it manually to 0. The multiple-exposure program can be canceled at any time by setting the number of multiple exposures to 1. To cancel a programmed multiple-exposure sequence before it has been shot, however, set the number of exposures to 1, set the lens to Manual focus, cover the lens with the lens cap, set the Command Dial to Tv or M, set a fast shutter speed, and snap the next exposure so that the film will be transported to the next frame.

Don't forget to alert your film processing lab when you're dropping off a roll with multiple exposures on it so that the multiple-exposure frames should be printed and not be presumed to be faulty. The easiest way to do this is to make sure that "Print All" is indicated on the Special Instructions portion of the film envelope.

Image Composition

The sophisticated metering and focusing systems of the Rebel-series (EOS 1000, 500, 300 series) cameras can produce photographs that are technically accurate. It is up to you, the photographer, however, to select a subject and create an interesting image. To do this, you must learn to "see," or visualize, how the resulting photograph will look. This involves understanding the effects of different focal length lenses and how elements such as color, framing, lighting, and viewpoint create visual interest.

Focal Length

A 50mm lens (or a zoom lens set at 50mm) "sees" like the human eye (it has about the same angle of view, or visual area). Pictures shot at this focal length are perceived as "normal"—what the human eye is used to seeing. As the focal length decreases, the angle of view increases. Lenses in the wide-angle range (14mm to 35mm) include more of the scene in the photograph as a result of the greater image angle. Landscapes, architecture, and building interiors are just a few of the subjects commonly photographed with wide-angle lenses.

When the lens' focal length is longer than 50mm, the viewing angle becomes smaller, and a smaller segment of the scene will fill the frame. This gives the photographer more control over what is included in the frame, as well as allowing a comfortable distance from the subject and still have the subject appear fairly large in the frame—one reason that moderate telephoto lenses (80mm to 200mm) are popular for portraiture and super telephotos (300mm and above) are used for photographing wildlife.

⟳ **An image like this, which exhibits converging vertical lines and exaggerated perspective, requires you to get in close with a wide-angle lens. You can minimize that kind of distortion by taking the photo from a greater distance with a telephoto lens.**

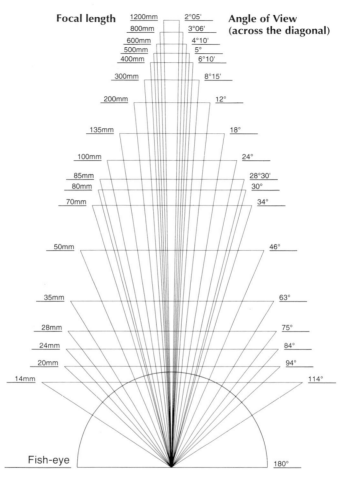

Focal length **Angle of View (across the diagonal)**

Focal length	Angle of View
1200mm	2°05'
800mm	3°06'
600mm	4°10'
500mm	5°
400mm	6°10'
300mm	8°15'
200mm	12°
135mm	18°
100mm	24°
85mm	28°30'
80mm	30°
70mm	34°
50mm	46°
35mm	63°
28mm	75°
24mm	84°
20mm	94°
14mm	114°
Fish-eye	180°

This chart shows the relationship between focal length and angle of view. In all cases, the angle of view is measured on the diagonal of the image.

When the focal length is changed *without altering the camera's position,* the scale of reproduction changes in direct relation to the new focal length. For instance, if the new focal length is shorter, the subject will be reproduced smaller and the imaging field will be larger. On the other hand, if the focal length is increased, the resulting photo will have an increased scale of

reproduction, while an increasingly smaller segment of the original subject will be reproduced.

The amount of information recorded in the picture will be in the exact ratio that the different focal lengths are to each other. A 35-70mm zoom lens doubles the scale of reproduction; a 35-135mm zoom lens changes the scale by approximately a factor of four. A 35mm focal length, for example, will reproduce everything at half the size obtained with a 70mm focal length; at 140mm, the scale of reproduction is double that obtained with a 70mm lens. An object that appears .75 inch (2 cm) high through a focal length of 35mm will appear 3 inches (8 cm) high—four times taller—with a 140mm lens. No change in perspective, only a change in the scale of reproduction.

Depth of Field

Depth of field is the area in front of and behind the plane of focus that is perceived as being in focus. It is generally distributed 1/3 in front of the plane of focus and 2/3 behind the plane of focus. The focal length of the lens affects not only the scale of reproduction, but also the depth of field. The greater the focal length of the lens, the shallower the depth of field; the wider the lens' angle of coverage, the greater its depth of field at any given aperture. A wide-angle lens, therefore, has more depth of field than a normal or telephoto lens. Because a telephoto lens has a large scale of reproduction and the range of apparent focus is reduced, telephoto images have less depth of field. Conversely, a wide-angle lens reduces the scale of reproduction, so the depth of field appears to be greater.

The Rebel 2000 features a depth-of-field preview button on the left below the lens release button. This button, which operates only in P, Tv, Av, and Manual modes, closes the lens diaphragm down to the actual picture-taking size and allows the photographer to visually preview the effect on the viewing screen.

Rebel series cameras prior to the Rebel 2000 have no depth-of-field preview button, but you can determine the range of apparent focus by using the DEP or A-DEP mode (depending on the model in use). Once this mode is selected, the farthest and closest points of the desired depth of field are covered by two of

The people in the background give scale to this photograph and help to exaggerate the height of the steps.

the seven focusing sensors (in A-DEP mode) or are within the wide AF metering field (in DEP mode). The aperture required to provide the depth of field and the shutter speed needed for proper exposure are computed and set by the camera. If the values shown in the viewfinder display and LCD panel are acceptable, you can release the shutter.

If the smallest aperture value blinks in the viewfinder, the desired depth-of-field range (based on the information falling within the wide AF field or under the focusing sensors) cannot be realized. Frequently, it is better to focus on a closer object than to adjust the focus to accommodate a sensor farther in the background. (See pages 15 and 68 for more information on DEP and A-DEP modes.)

Selective Focus

The human eye can *see* objects within a viewing angle of 46°, but it is capable of *focusing* only at a much smaller angle. Sharpness is concentrated within the range of greatest interest, so our perception is selective. Once you understand this, you can be varied about depth of field and use it for creative effects. You can set focus to create a mood, emphasize an object, or eliminate distractions. For example, depth of field and selective focus can be used to emphasize a subject by having only a small part of a picture in sharp focus and dissolving the remaining image area into a blur. This can be done by using a telephoto lens, setting a large aperture, and decreasing the camera-to-subject distance. By maximizing depth of field, it is possible to create pictures with everything from foreground and background in focus so the viewer's eye is led into the scene. The plane of apparent sharpness can cover vast distances or thin slivers of space.

The eye is drawn to a sharp image more readily than one that is out of focus. This makes experimenting with selective focus a particularly effective way to accentuate a subject. A portrait in front of an out-of-focus background tends to make the eye linger on the model. Or, a building in the distance can be framed by softly blurred branches in the foreground.

Perspective

When you change focal lengths but maintain the same camera position, the reproduction scale of everything in the photograph is altered; when both the focal length and camera position are changed, the size relationship between objects in the foreground and background changes as well. For instance, if you double the focal length of your zoom lens (e.g., from 35mm to 70mm) and also double your shooting distance, an object in the foreground will be rendered the same size in both photographs. Objects in the background, however, will be larger and will therefore appear closer in the photograph taken with the longer lens.

If you cut both the shooting distance and focal length in half, the subject will have steep perspective. The size of objects in the

The low angle from which this photo was taken gives it a strong perspective. The students in the foreground add life, scale, and interest to the image.

foreground is emphasized, background objects appear small, and the vanishing lines converge quickly.

This image composition technique is employed deliberately by photographers to compress image information, relate objects, or de-emphasize unimportant elements in their photographs. For example, many photographers will reach for a wide-angle lens for a shot of pedestrians bustling down a narrow alleyway. In most cases, the result is not satisfactory because the wide-angle lens changes the relationship between the foreground and the background so that the close-up range is reproduced relatively large and the background extremely small. To convey the mood and atmosphere of an overcrowded alleyway, step back farther and use a longer focal length. The shorter lens makes the alley seem elongated, while the longer lens gives the impression of compressed space so the alleyway seems to be filled with lots of people milling around.

Pointing the camera upward at a subject will distort perspective, exaggerating the subject's size and creating a very powerful impression.

Using a wide-angle lens is another way of exaggerating perspective. It can be quite effective when used to photograph the right subject.

This photo is packed with information from corner to corner. Fill the frame, include a range of highlight and shadows, and use perspective to create an interesting composition.

Framing the Subject

Framing is a compositional technique. The size of the subject, as well as where and how it's placed in the photograph, can be used to emphasize a subject and create specific feelings about it. Select your subject and determine why it would be of interest. How do you want people to see this subject? In making these selections, consider a few aesthetic basics.

The most basic rule of framing is to fill the picture frame with the subject. The image frame should show only what is important. Get in close and crop out unwanted elements that may distract the viewer; getting sufficiently close to the subject or changing the lens' focal length to place only the subject within the frame are two ways of doing this.

Lighting

Lighting can be an effective way of emphasizing the subject. With a little practice, you can master the use of light to direct the

viewer's eye to the most important part of the image. Light areas are more conspicuous than dark areas and therefore draw attention to that area of the photograph. You can easily control where the viewer looks with a single spotlight strategically directed at the main subject. The same effect can be provided by nature, such as when a sunbeam breaks through a cloud and lights up an alleyway or a forest path.

Light itself can be a great subject. For example, light and shadow often form dramatic patterns and shapes that can make interesting photos. A view through a window or a gated passageway can present limitless possibilities for examining and documenting the contrast between highlights and shadows.

Color

Colors can have a strong influence on image composition. A color can generate a specific feeling; for example, yellow is usually associated warmth and cheer, red with aggression and passion. Contrasting colors create visible distinctions—a person dressed in red will stand out in a green meadow.

Bright or light-colored areas will draw the viewer's eyes. Though this usually works to your advantage, it could inadvertently also work to your disadvantage, in that such areas could draw attention away from your intended subject. Before snapping the photograph, search the frame for bright or colorful objects that might so detract.

Colors also affect how the viewer perceives the position of elements within the frame. In general, warm colors (red, orange, yellow) will move toward the foreground of a picture, while cooler colors (blues, purples, greens) will recede; this is particularly true for blue. Often, this characteristic is not given enough consideration when small subjects or still lifes are shot.

Perception

A composition that can be understood by the viewer creates interest in the picture. Graphic elements provide visual cues that promote understanding. A graphic image composition, therefore, will promote interest.

Repetition can be used for creative effect. Even if the subject is unrecognizable, the graphic pattern in a photograph grabs attention.

The dynamic diagonal lines of an otherwise boring subject give the image a feeling of rhythm and motion.

All too often, photos appear as if the photographer just discovered the subject by chance and shot it from wherever he or she happened to be standing at the time. This is hardly ever the best possible shot. The interesting elements of the scene were presented ineffectively because the photographer neglected a number of considerations.

First, the photographer must consider the difference in the way the camera and eye view a subject. The human eye's perception is selective; the camera's is not.

If the eye is interested in a subject, the area surrounding the selected subject (to the right and left, foreground and background) is easily ignored. Selective perception is why so many photos are taken of trees growing out of people's heads and how too many distracting or uninteresting little objects end up next to the main subject. In this style of picture-taking, the camera is just a recording tool that indiscriminately records everything that falls within its field of view.

How the surroundings will appear in the photo is normally not visible in the viewfinder, which shows the image only as it would appear if the photo were shot at the lens' largest aperture and not with the actual distribution of light and shadow or depth of field that will result in the final image. Thus, errors in image composition are noticed only after it is too late.

But the differences between the way we perceive a subject and how it appears on film are even greater. Let's say, for example, that you discover a subject that has a clear geometric form, such as a door or a store-window display. The door and window have vertical and horizontal lines that form 90° angles at the points of intersection. In nine photographs out of 10, however, the angles will not appear to be 90°—and you'll also discover that either the vertical or horizontal lines will not be parallel to the image edges. The graphic and geometric image of the door has not been transferred accurately onto film.

This is not the camera's fault. It is instead the result of transferring a three-dimensional object onto a two-dimensional medium. When reproduced in perspective, a rectangle becomes a trapezoid, and a circle becomes an ellipse. A truly distortion-free image can be achieved only when photographing a two-dimensional subject that is parallel to the film plane. Unless this parallel arrangement exists, the subject appears distorted. Any miniatur-

ization, reduction in length, or convergence of parallel lines constitutes a distortion in perspective. For this reason, it is usually wasted effort to attempt to take pictures of the subject as seen by the human eye. Instead, the reverse approach—learning to view the subject as seen by the lens—is guaranteed to be more successful. Also, arrange and simplify the composition as much as possible; leave out extraneous information so the subject becomes more prominent.

Subject Recommendations

This section discusses the most favorable operating mode, accessories required, and possible problems encountered in photographing a variety of subjects. It is meant to offer ideas and facilitate entry into areas that you may not have explored as yet. Of course, none of the tips and hints offered are musts, but what applies to other creative activities applies here as well—only those who dare to try, to experiment, will produce an exceptional product.

With the use of a super-wide-angle lens, architectural photos can be given a unique interpretation, with strong and dynamic lines.

Architecture

The comprehensive field of architecture uses almost all picture-taking techniques, in almost any one of the Rebel 2000's exposure modes. To greatly decrease the convergence of vertical lines when photographing tall buildings, use a telephoto lens and position the camera farther from the subject. If the height of the building is to be emphasized, choose a wide-angle lens.

To ensure that the entire building will be in focus, use either Automatic Depth-of Field (A-DEP) mode or Aperture-Priority (Av) mode and a small aperture. Using a long lens and a small aperture to produce sufficient depth of field, however, can result in a shutter speed that is too slow for a hand-held shot. Be prepared by bringing along a tripod and fast film, or use a fast film and a lens with image stabilization (IS) technology.

Astronomy

Exposure times of up to four hours with an aperture of f/8 and using ISO 100 film are required to record the circular motion tracks of the stars. To define the approximate dimensions of the picture, point a strong pocket flashlight at the dark sky and view the image through the viewfinder. Use the flashlight's beam to align the frame. A tripod and the accessory Remote Switch (RS-60E3) are required.

Babies and Children

When photographing children, the number-one rule for better photos is: Change your viewpoint. Instead of towering over the child and pointing the camera down, kneel or sit down so that you are at eye level *with* the child. Portrait mode is ideal for taking baby pictures or posed portraits of children. If the child is active, you may want to use Full Auto mode and devote your attention to the subject. In both modes, the built-in flash unit on the Rebel 2000 is activated automatically if needed. A blinking aperture display signals a potentially poor background exposure.

Coins and Jewelry

An excellent gold tone can be achieved when you're shooting coins and jewelry by mounting a polarizing filter to the camera and the source of illumination. A circular rather than linear polarizing filter must be used on Rebel-series cameras to accommo-

date the autofocus system. Linear polarizing film screens, available from professional photo dealers, are inexpensive and can be used on light sources (lamps or flash units).

Copy Work (Reproductions)

Because copy work is largely done of two-dimensional objects, the film plane must be aligned precisely parallel to the subject. In addition, uniform illumination is required; artificial light can be used to control unwanted reflections. We recommend that you use Manual mode and a KODAK Gray Card to determine the exposure values. The Canon EF 50mm f/2.5 macro lens is ideal for this purpose. Low-sensitivity, fine-grain films (ISO 25 to ISO 50) should be used for black-and-white photographs. Only line drawings require special copy film.

Families and Family Occasions

If you own a Canon Speedlite flash unit, use it to take bounce flash exposures of family gatherings. To make your job easy, set the camera on Full Auto mode and leave the rest to the camera. The Rebel 2000 ensures optimal balance of flash and ambient light exposure in bright rooms. If mood and atmosphere are important, special effects can be achieved with flash and time exposures in Aperture-Priority mode. Small zoom lenses or focal lengths between 28mm and 135mm are ideal for family shots. The higher the telephoto setting, the softer the flash and the better the depth of illumination. When wide-angle, direct-flash shots are taken, only the adjusted shooting distance is well illuminated, and the amount of flash falloff is significant. Bounce flash and a long shooting distance should be used when the flash range must be extended—to illuminate people seated down the length of a banquet table, for instance.

Fireworks

A tripod, focal lengths between 100mm and approximately 200mm, a bulb time exposure, and a standard aperture of f/5.6 are a good start for shooting fireworks. Open the shutter and wait for about three to five bursts of fireworks before closing the shutter again. Pictures are most effective if they include clear and generous silhouettes of houses, trees, or people.

Flowers

When shooting flowers, use Close-Up (macro) mode, preferably with a telephoto or zoom lens with a focal length over 100mm or one of the Canon macro lenses such as the EF 50mm f/2.5 compact macro. More exciting from a creative standpoint is the telephoto range, which becomes a macro range in all EF zoom lenses.

If you choose to use Full Auto mode, shadow or backlit areas are filled in automatically with flash. A tripod, the Remote Switch RS-60E3, and patience are recommended for the Rebel 2000 when taking close-ups.

Groups

Use A-DEP mode when both people and the background need to be in focus. Fill flash is not possible in this mode. It is better to switch to Full Auto mode, because fill flash is added automatically.

Landscapes

Rebel cameras have a separate program for landscapes, designed mainly for wide-angle lens shots. If you prefer to use telephoto lenses, it is best to use Full Auto mode.

When choosing the framing for a wide-angle landscape, pay special attention to the foreground to assure that there are no distracting elements present. Also, make sure to place interesting picture elements in the middle and background. Evaluative metering produces he best results.

Macro Exposures

Macro (close-up) shots are easiest when you use the Rebel 2000's Close-Up mode with an EF 50mm f/2.5 macro, EF 100mm f/2.8 macro, or any EF zoom lens. Photographers who want to get closer to the subject than 1:1 will need to use a bellows (not yet available from Canon).

Night Exposures

Night Scene mode on the Rebel 2000 can automate the taking of many types of night photographs (see page 54), but sometimes this is not the best method for shooting true night photographs. Night exposures not taken with this mode generally require a minus exposure correction (at least when slide film is used) when

they are supposed to appear to have been taken at night. The best "night" exposures are made at dusk.

Portraits

For this work, of course, use the Portrait mode, found on all Rebel cameras. For impressive pictures, get close to the subject—close enough that either just the subject's head or both the head and torso fill the picture—by using the telephoto range of a zoom lens. Focus on the subject's eyes by directing the active AF sensor at them and applying light pressure on the shutter release button. With pressure maintained on the shutter release, recompose the frame and shoot.

Sports

The fine art of snapshot photography can be practiced particularly well at sporting events. Almost any type of sport has an ideal observation point; at automobile, motorcycle, or bicycle races, for example, it is at a curve. These shots can be particularly impressive by using A-DEP mode and continuous film advance. Field games are best observed near the goal.

Sports mode or Shutter-Priority (Tv) mode are the two modes most often used for shooting sports. When using the latter, a shutter speed of at least 1/1000 second should be set to freeze action. A slower speed will blur the action, and sometimes that effect is desirable. For shooting photos at the start and finish lines in track-and-field events, Sports mode and the Rebel 2000's AI Servo AF mode will produce the best results when competitors are running toward the camera.

Water

This relatively difficult subject often requires long exposure times because motion blurs that accentuate the water's flow are often desirable in pictures of brooks, rapids, or waterfalls. This means using a tripod and Shutter-Priority mode. Take a series of shots to test the effect. The longer the shutter speed, the more the water will be blurred.

On calm days, lakes, ponds, and canals frequently provide brilliant reflections. The most intense colors are produced with the sun at your back and a circular polarizing filter on the lens. Using a wide-angle lens with Landscape mode allows you to photograph close to the water.

There are many different ways to photograph boats for dramatic effect. They can be shot at a slight angle from above so they are surrounded only by water, or from below to set them off against the sky and distort their shape slightly. If the boat is moving, Shutter-Priority mode can be used to set a fast shutter speed to stop action or a slow speed to create motion blur. Another effective approach to photographing boats is to use a diagonal composition, which emphasizes action, motion, and direction.

Weddings

Here, everything can be photographed in Full Auto or Program mode with flash (a Canon Speedlite flash unit is recommended for soft illumination). Groups can also be photographed using these modes. Use fill flash when you take pictures of subjects in the shade.

When taking photos with a telephoto lens, remember that telephoto shots are always better when illuminated with flash. The aperture should be opened and set to f/5.6; selecting a smaller aperture restricts the shooting range of the flash too much. We advise that you wait a few extra moments after the flash-ready indicator has lit up before releasing the shutter.

Winter Snowscapes

Lighting is of utmost importance when shooting snow. When light grazes the surface of a snow-covered field, depth is created. Backlighting is the most effective but also the most difficult type of lighting with which to shoot a snowy scene. Because of the intensity of light reflected on snow, we recommend that you meter manually using a KODAK Gray Card or another surface with medium reflectance.

A skylight filter can be used to prevent excessive blue coloration in shadow areas. Be careful when using a polarizing filter in high altitudes, because it can darken the sky considerably.

To capture the effect of falling snow, use an extremely slow shutter speed. A large foreground and a relatively dark background are desirable.

Exposures of snow-covered fields taken at dusk or night are particularly powerful. This is easily done in Aperture-Priority mode. Another option is to take a series of exposures with minus exposure compensation.

Tips for Better Travel Pictures

1. Check your equipment—especially batteries—in advance, and take an extra set of batteries.

2. Take the type of film that is appropriate to your destination—fast film (high ISO) for rainy places or forests, slow film (low ISO) for the seashore or desert.

3. Shoot evocative rather than just illustrative pictures. Do not confine yourself to strict documentation; try to capture the scene's mood.

4. Learn to observe. Often, having patience is more important than staging a scene. Hold an empty slide mount in front of your eye to learn to see in a photographic frame.

5. Move in as close as possible to the subject, either physically or with a telephoto or zoom lens.

6. Instead of capturing extensive series using the same framing, make the subject stand out by taking the photographs from different perspectives.

7. Do not just change the focal length; change the shooting distance, and thus the perspective, as well. Try to take photographs from the perspective of a frog or bird.

8. Force yourself to see image compositions and graphic relationships. Only those who master the rules of classic image composition will have the knowledge to transcend them.

9. Always aspire to achieve the best optical and technical quality in your pictures. Examine the viewfinder image carefully, and use a tripod or monopod, polarizing filters, and fill flash.

10. Take pictures in extreme lighting and weather situations and at times of the day, such as early morning or dusk, that provide dramatic and unexpected results.

11. Always ask permission before taking pictures of people.

Canon EF Lenses

A Brief History of Interchangeable Lenses

In its infancy, photography offered no distinctions among wide-angle, normal, and telephoto lenses. In 1890, the first photographic Galilean telescope, capable of magnifying a subject four times, was introduced. Only after Oskar Barnack invented small-format, 35mm photography, however, did it suddenly make sense to manufacture lenses with greatly varying focal lengths and fast apertures for photographic purposes.

In addition, along with the change from romantic photography to the new realism and the first successes of photojournalism came an increased demand for interchangeable lenses. In the 1960s, interchangeable lenses became a standard feature of 35mm SLR cameras.

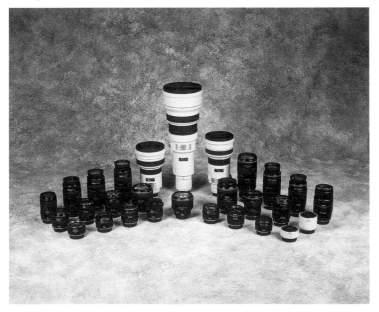

From extreme wide angles to extreme telephotos, Canon makes a lens to suit every photographic need.

Canon's Contribution

Canon has always considered having its own complete line of lenses to be crucial to high-quality photography. It is not surprising, therefore, that pioneer efforts in this field are frequently connected with the Canon name. This includes technical equipment features that have become quality concepts in lens construction. For example, Canon has pioneered such ideas as internal focusing, lenses of calcium fluorite, aspherical lens surfaces (both ground and polished, and glass-molded aspherics), and most recently image stabilization (IS) lenses that can be used, handheld, at much slower shutter speeds.

The era of the Canon FD lenses ended with the introduction of the first EOS 650 in 1987. There were things that the Canon lens designers wanted to do that simply could not be done within the constraints imposed by the FD mount, primarily due to the relatively narrow diameter of the mount itself. For instance, certain high-speed lenses required rear glass elements that were too large in diameter to fit into FD mounts. Also, Canon realized that mechanical lens linkages were simply not accurate or durable enough for the lenses of the future.

The Canon EF Mount
The result of all of this was that Canon's engineers decided to

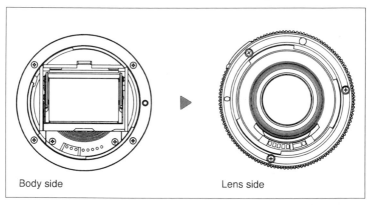

Body side Lens side

This drawing shows the lens bayonet mount of the camera (left) and the rear of the lens (right). Note the electrical contacts on both, which mate when the lens is mounted.

make a complete break with the FD mount tradition and introduce a totally new lens mount—the EF (electronic focus). The Canon EF mount is much larger in diameter, features a simple bayonet design, and has no mechanical linkages between the camera and the lens. Not only do the gold plated electrical contacts convey information between the camera and the lens, they also carry the electrical power for the autofocus motor and the diaphragm motor, eliminating the need for a separate battery compartment in the lens. Canon engineers concluded early in their research that the autofocus motors belonged in the lenses, where the motors could be placed as close as possible to what they actually moved; in addition, each lens could be fitted with a motor best suited to its needs and specifications. This has resulted in the design of several different types of motors for EF lenses.

Arc Form Drive

The first type of motor Canon designed for EOS lenses was the Arc Form Drive (AFD). This is a very traditional small electrical motor whose components are arranged in an arc shape so that the motor fits easily into a lens barrel. While the AFD works very well, it wasn't quite fast enough for most applications, and it has been replaced with a new generation of motor. Because of special design considerations, one Canon EF lens uses a traditional small electrical motor with a long drive shaft. This was the only type of motor Canon could fit to the 100mm f/2.8 macro lens, which has an exceptionally long extension.

Ultrasonic Motors

The most advanced motor now being used is hardly a motor at all in the conventional sense of the word; it is simply two metal rings with special surfaces on their mating sides. These rings are held in contact by springs, one fixed in position while the other free to turn. An electrically excited piezoelectric crystal acts as an oscillator at ultrasonic frequencies to vibrate the rings. Because of the nature of their surfaces, the standing wave generated in the rings causes them to rotate against one another. Since one ring is fixed in place and the other one turns, the direction of rotation and speed of the turning ring are controlled by the frequency and intensity of the wave generated. Canon refers to this unusual device as an Ultrasonic Motor (USM).

The ring-type USM motor uses high-frequency vibration to drive the lens. This motor is the fastest and quietest, but is expensive to manufacture.

The newer Micro USM operates on the same principles, but is suited to mass production and is much less expensive. It is being used in place of AFD motors on all newer Canon AF lenses.

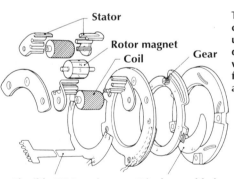

Stator

Rotor magnet

Coil

Gear

Flexible PC Board Diaphragm blade

This diagram shows the construction of Canon's unique, electrically driven diaphragm mechanism, which uses stepper motors for precision and repeatability of aperture setting.

Initially, the manufacture of USMs was extremely expensive and quite complex; relatively small numbers, therefore, were built, and the first generation of USM (L-1) was used only in professional lenses. Continued research on USM technology has resulted in a total of three generations of USMs, each one

designed to suit a specific purpose. The largest and most powerful is the L-1, a ring-type USM built into most Luxury (L-series) super-telephoto lenses and large-aperture lenses. Next is the M-1 (also a ring-type motor), which is used in a wide variety of consumer-level lenses. Unlike the L-1, which has an electronic manual focusing system, the M-1 USM has a less expensive mechanical manual focusing mechanism. The third generation is the Micro USM, introduced in 1992 with the EF 35-80mm f/4.0-5.6 USM. The Micro USM, which is not a ring-type motor, is used in Canon's entry-level EF lenses. It is faster and quieter than the DC Micro Motor it has replaced in many lenses.

The advantages of these special ultrasonic motors are many: they permit automatic focusing in almost all fields of professional photography; they do not have a clutch to prevent an immediate start, and thus are capable of a rapid response to even the most difficult automatic focusing problems; ring-type USM technology does not require the photographer to change settings on the lens for manual focusing; and, because an inaudible frequency of 29 to 31 KHz is responsible for the lenses' drives, USM lenses are virtually silent. This is a big plus for photographers who do not want to call attention to themselves.

EF Lens Performance
At the time the first EOS models appeared, 13 EF lenses were announced. Since then, many more EF lenses have been intro-duced. The high proportion of zoom lenses covering focal lengths from 17mm to 400mm is impressive. Almost a third of the zoom lenses and numerous fixed focal lengths in extreme performance ranges (L-series lenses) are of professional caliber. Canon's optical systems in general and the EF lenses in particular are so well crafted that possible image aberrations and their causes need be given relatively little attention by the photographer.

The considerable challenge to optical engineers requires that they reduce aberrations appropriate to the problem to be solved by the lens, thus preventing residual aberrations—which occur even with proper use—from being conspicuous. Technical and scientific use and many professional applications require not only good quality, but the best quality, lens. In these cases, it is impor-tant that maximum-performance quality of lens and camera be noted with the "L" (Luxury) designation.

"EF mount" distinguishes every interchangeable lens that is compatible with Canon EOS system cameras. All of these lenses can be used on Canon's 35mm EOS SLRs, on Advanced Photo System EOS SLRs, and on VL-Mount interchangeable-lens camcorders (via an adapter). "L" identifies ultra-professional (Luxury) lenses, and "USM" indicates that a lens is focused by an Ultrasonic Motor. The abbreviation "TS-E" identifies tilt-and-shift lenses with electrical diaphragm operation, and "macro" indicates that a lens is specifically designed for the close-up range, allowing significant magnification. The latest addition to this letter code designation is IS, which stands for image stabilization. This innovative technology uses a moving optical wedge and gyroscopes coupled to an electronic system to keep the image relatively stable even when the lens is not. In practice, this design is particularly useful when working from moving platforms, such as boats, and when taking photographs without a tripod or other support. With IS, I (Bob Shell) have found that I can hand-hold this lens, while bracing my body against a convenient support, at shutter speeds as slow as 1/8 second—unheard of when using a lens without IS technology. The practical development of IS is one of Canon's greatest technological breakthroughs, providing the photographer much greater freedom.

Lens Care

Although the electrical contacts on the back of EF lenses are much less delicate than pins and levers, they still must be protected from environmental dust and dirt and particularly from fingerprints when the lens is not on the camera. The same goes for the rear glass of the lens, which is easily scratched. Always put a rear lens cap on a lens as soon as it is taken off the camera, and keep it there until just before the lens is again mounted onto the camera. Likewise, front caps should be left on all lenses when they are not in use.

If you do get dirt or dust onto the front or rear glass of the lens, you can remove it easily and safely. First, simply see if it will blow off. Camera dealers sell small squeeze-bulb blowers for this purpose, or you can buy an ear syringe from a drugstore. Gentle puffs of air will usually get rid of most dust and grit. If you encounter

stubborn material, then you can resort to the brush, which should always be a soft camel's hair brush. Use this in a sweeping circular pattern starting at the center and working toward the edge of the lens. Hold the lens either sideways or with the glass surface to be cleaned, pointing downward so that gravity will carry away the offending matter. Then try the blower again.

If you still don't have success, take a lens-cleaning tissue or a special lens chamois and wipe gently, again in a circular motion starting from the center. If even this does not work, moisten the tissue with a drop or two of lens cleaning fluid and try again, exerting only very gentle pressure. If none of these work, take the lens to a professional.

Don't be a fanatic about dust, however. A few specks of dust on the front of your lens, a few on the rear, or even a few on the inside glass elements will not have a noticeable effect on your photos. Reasonable cleanliness is important, but do not rigidly cling to the idea that a single dust speck will ruin your photos.

Lens Characteristics

Lenses are characterized by two features: maximum aperture (or lens speed) and focal length. Maximum aperture refers to the size of the largest diaphragm opening (also called lens aperture) available on the lens; the diaphragm controls the amount of light that passes through the lens. In effect, the diaphragm opening works similarly to the iris of the eye. Apertures are expressed as f/stops, which are actually fractions. For example, f/16 is a smaller aper-

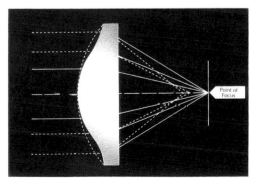

A normal, spherical lens (represented by dotted lines) focuses rays of light coming from the lens' outer edge at a point different from where rays passing through the center of the lens are focused. An aspherical lens corrects this so that all rays focus on the same plane.

Point of Focus

ture than f/11 (think of it as the difference between 1/16 and 1/11); therefore, f/2.8 is a relatively large aperture, and an aperture of f/2 is larger yet. Opening the lens one full stop allows twice the amount of light to pass to the film. The amount of light is cut in half whenever the aperture is closed down to the next higher f/number (i.e., from f/11 to f/16).

The second lens parameter, now indicated in millimeters, expresses focal length. This is usually considered the most important lens reference value, and it is independent of any film format. Inside each lens assembly, light rays coming from infinity are bent so that they meet at a point of focus. The distance from the rear nodal point (optical center of the lens) to the film plane is defined as focal length. The angle of view covered by a lens is a function of focal length. A larger angle of view becomes a wide-angle lens, a small image angle becomes a telephoto lens, and a variable angle of view is characteristic of a zoom lens.

Canon Lens Line
(Current as of date of publication)

Fixed Lenses
Canon EF 14mm f/2.8 L USM
Canon EF 15mm f/2.8 Fisheye
Canon EF 20mm f/2.8 USM
Canon EF 24mm f/1.4 L USM
Canon EF 24mm f/2.8
Canon TS-E 24mm f/3.5 L
Canon EF 28mm f/1.8 USM
Canon EF 28mm f/2.8
Canon EF 35mm f/1.4 L USM
Canon EF 35mm f/2.0
Canon TS-E 45mm f/2.8
Canon EF 50mm f/1.0 L USM
Canon EF 50mm f/1.4 USM
Canon EF 50mm f/1.8 II
Canon EF 50mm f/2.5 Compact Macro
Canon EF 85mm f/1.2 L USM
Canon EF 85mm f/1.8 USM
Canon TS-E 90mm f/2.8

Canon EF 100mm f/2.0 USM
Canon EF 100mm f/2.8 Macro
Canon EF 135mm f/2.0 L USM
Canon EF 135mm f/2.8 with Soft Focus
Canon EF 180mm f/3.5 L Macro USM
Canon EF 200mm f/1.8 L USM
Canon EF 200mm f/2.8 L II USM
Canon EF 300mm f/2.8 L USM
Canon EF 300mm f/4.0 L IS USM
Canon EF 300mm f/4.0 L USM
Canon EF 400mm f/2.8 L II USM
Canon EF 400mm f/5.6 L USM
Canon EF 500mm f/4.5 L USM
Canon EF 600mm f/4.0 L USM
Canon EF 1200mm f/5.6 L USM

Zoom Lenses
Canon EF 17-35mm f/2.8 L USM
Canon EF 20-35mm f/3.5-4.5 USM
Canon EF 22-55mm f/4.0-5.6 USM
Canon EF 24-85mm f/3.5-4.5 USM
Canon EF 28-70mm f/2.8 L USM
Canon EF 28-80mm f/3.5-5.6 II
Canon EF 28-80mm f/3.5-5.6 V USM
Canon EF 28-105mm f/3.5-4.5 USM
Canon EF 28-135mm f/3.5-5.6 IS USM
Canon EF 35-80mm f/4.0-5.6 USM
Canon EF 35-80mm f/4.0-5.6 III
Canon EF 35-350mm f/3.5-5.6 L USM
Canon EF 55-200mm f/4.5-5.6 USM
Canon EF 70-200mm f/2.8 L USM
Canon EF 75-300mm f/4.0-5.6 IS USM
Canon EF 75-300mm f/4.0-5.6 III
Canon EF 75-300mm f/4.0-5.6 III USM
Canon EF 80-200mm f/4.5-5.6 II
Canon EF 100-300mm f/4.5-5.6 USM
Canon EF 100-300mm f/5.6 L
Canon EF 100-400 f/4.5-5.6 L IS USM

Extenders
Canon EF 1.4x
Canon EF 2x
Life-Size Converter EF

Three Lenses for the Beginner

The beginner is faced with a very difficult choice. With so many lenses to pick from and so many of them seemingly similar, how do you decide which lenses to buy? To start with, we recommend taking care to shop at a reputable photo dealer. Beware of bargain-priced camera outfits that are advertised something like, "Canon EOS Rebel G with three lenses, . . . only . . ." and at a ridiculously low price. The old rule applies: Know what you are buying and from whom you are buying it.

It used to be that most 35mm cameras were sold with a 50mm lens as a standard package. This was so much the case that the 50mm came to be known as the "normal" lens, and these lenses are still often referred to that way. Canon offers three different "normal" lenses for EOS cameras—the 50mm f/1.0 L USM, the 50mm f/1.4 USM, and the 50mm f/1.8 II—and for some photographers any one of them would be the right choice. More often today, though, photographers are finding that they are happier with a "normal" zoom. Author Bob Shell's personal "normal" lens is the 28-80mm f/2.8-4.0 L USM, which he has used for some years. It was an expensive lens, but it is incredibly sharp and replaces a minimum of three fixed lenses, the 28mm, 50mm, and 80mm.

Canon makes two separate series of EF lenses, which may be described as standard and super; the L (Luxury) series is Canon's top-of-the-line professional lens line. All of them have superlative performance characteristics, and all of them are expensive. But if your goal is to buy absolutely the best optics possible, nothing else can touch them. If money were no object, we would recommend you own three lenses: 17-35mm f/2.8 L USM, 28-70mm f/2.8 L USM, and 100-300mm f/5.6 L.

A more accessible three-lens kit would consist of the lower-priced 20-35mm f/3.5-4.5 USM, and 28-135mm f/3.5-5.6 IS USM, and the standard 100-300mm f/4.5-5.6 USM. These lenses are very good, and many professionals do use them. In the case

This 20-35mm variable-aperture wide-angle zoom lens is ideal for many applications, including interior photography and photojournalism.

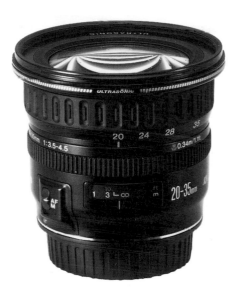

of the first two, the economical price is achieved by making them slower, but this also makes them smaller and lighter, which is an advantage. In the case of the 100-300mm, the difference is that the L uses exotic types of glass and has a higher degree of color correction.

Whether the slower and less expensive wide-angle and normal zooms, and the less expensive glass, will meet your needs depends entirely on the type of photography you do and your own critical standards. If you habitually work outdoors in bright light, they would certainly be adequate. If your forte is taking low-light photos in available light, then you would want the faster lenses and might bypass zooms altogether in favor of the very fast fixed focal length lenses. Or, if you do a lot of close-up work, one of the three macro lenses might make more sense to you. What *is* important is to know in advance what it is that you want to do photographically and then match the lenses you buy to the purpose. It makes no sense to buy a particular lens if you have no use for it just because it will impress people.

What follows is a discussion of a representative range of Canon EF lenses. For a more comprehensive discussion of Canon lenses, see *Magic Lantern Guide to Canon Lenses.*

Fisheye and Super-Wide-Angle Lenses

Fisheye lenses are examples of barrel distortion gone mad and totally uncorrected. The only straight lines that are rendered straight are those that pass through the exact center of the image. The days when an image taken with a fisheye lens brought gasps of astonishment to an audience are long gone. Everyone has seen the fisheye effect—far too much, in fact. This is not to say that we renounce all use of fisheye lenses, just that they should be used judiciously. Canon's 15mm f/2.8 fisheye for EOS cameras is one of the best of these special lenses.

Canon has chosen to make a full-frame fisheye, not one of the kind that produces a small circular image in the center of the film; instead, it fills up the frame and provides an approximately 180° view from corner to corner. This lens can be used to produce highly exaggerated perspectives in views of interiors, as well as for sweeping panoramas of landscapes in which the distortion is not obvious unless the lens is tilted up or down. George Lepp, the well-known nature photographer, tells us that he uses the fisheye for very close flower photos, sometimes getting all the way down on the ground and looking up at the flower from below. Don't be afraid to try unusual methods like this; the photos may be spectacular and certainly will get you thinking about ways to use unusual perspectives.

Though they are perhaps not as riveting as photos taken with fisheye lenses, photos taken with super-wide-angle lenses can still be remarkably striking. These lenses lend themselves to providing unusual perspectives and opening up spaces indoors as well as outdoors. In the category of super-wide-angle lenses, Canon has two lenses of fixed focal length and three zoom lenses: the EF 14mm f/2.8 L USM, the EF 20mm f/2.8 USM, the EF 17-35mm f/2.8 L USM, the EF 20-35mm f/3.5-4.5 USM, and the EF 22-55mm f/4.0-5.6 USM.

The fisheye design allows barrel distortion to go uncorrected—distorting straight lines into arcs as they become farther from the image center—while the 14mm is a rectilinear design with maximum correction for distortion. In other words, if aligned carefully, the 14mm lens will provide images with a minimum of barrel distortion. Any wide-angle lens will produce distortion if tilted up or down, but rectilinear ones will have very little if

aligned carefully. For this purpose, an accessory bubble level that attaches to the camera hot shoe is a useful accessory, and is readily available from good photo shops.

One of the most important advantages of super-wide-angle lenses is that with them you can take in large areas from very short distances; this is particularly an advantage indoors in cramped surroundings. These lenses open up such surroundings, making them appear more spacious. Advertising photos of auto interiors are generally taken with wide-angle lenses for this reason; viewed through a 20mm, the cramped cockpit of a Lamborghini Diablo looks like the spacious interior of a limousine! Don't think that these lenses are just for indoors, however; they are also very useful out and about in the city. Just don't tip the lens up to get the tops of the buildings in—the exaggerated perspective of a super-wide-angle lens makes the buildings look as if they are falling down.

Canon EF 15mm f/2.8 Fisheye: The Canon EF Fisheye focuses down to 8 inches (20 cm). This value does not represent the distance of the subject to the front of the lens but to the film plane. Due to this extreme perspective and the small scale of reproduction, this focal length features extreme depth of field, so it is not necessary to use the lens' smallest aperture of f/22 when everything in the picture—from a few inches to the horizon—is to appear sharp.

The Canon EF 15mm f/2.8, a fish-eye with a 180° angle of view.

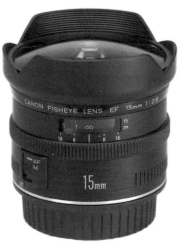

The built-in lens shade does not accommodate a standard screw-in filter. Therefore, the lens has a special snap-in filter mount. Filter gels, such as KODAK WRATTEN™ Filters, must be cut to 31 x 31 mm and inserted in the filter mount. From an optical point of view, it is of no consequence whether a filter is mounted in front of or within the lens.

In this lens, the optical system is comprised of eight elements in seven groups. The AFD focuses from infinity to 8 inches (20 cm) in exactly 0.36 second. The smallest subject area is 6.9 x 10.3 inches (17.1 x 25.7 cm). The lens length is 2.4 inches (6.2 cm), and the weight is 11.6 ounces (330 g).

Canon's EF 14mm f/2.8 L USM is a very sharp, high-speed, super-wide-angle lens.

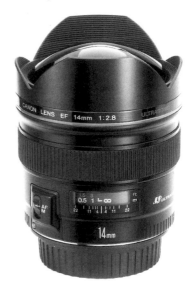

Canon EF 14mm f/2.8 L USM: This super-wide-angle lens continues the old FD lens tradition and expands the previous maximum super-wide-angle range of 20mm down to a fabulous 14mm. The most amazing feature of the EF 14mm lens is the USM motor. Until now, Canon has preferred the AFD motor for the wide-angle range because the distance transfer could work with different shooting ranges and produce different effects; this allowed the photographer to fine-tune in the close-up range. If, however, the 20-35mm zoom is described as having fast AF adjustment, extremely fast must be used to describe this lens.

This super-wide angle exhibits surprisingly little vignetting (although some is still evident in this focal length range). Also, typical distortion is very minor, thanks to the exceptional configuration of the optical system. Even though this system is principally based on the Canon FD 14mm lens, its optics have been redesigned completely. The second of the 14 elements in 10 groups is aspherical, which compensates for distortions along the edges. Astigmatism, which is particularly annoying at very short shooting distances, is neutralized by internal focusing. In so doing, the distance between the front lens and the focusing element changes as the distance is changed. Instead of a genuine lens hood, these lenses have an abbreviated lens hood, which also acts as a front lens protector to prevent scratching of the domed front lens. The lens' construction allows the insertion of a gel filter in the optical path; there is no conventional filter mount. The Canon 14mm super-wide-angle lens can be used in an exceptionally effective way, especially with a reproduction scale of 1:10 and a shooting distance of 10 inches (25 cm). When the close-up setting and depth of field are used optimally, a sharp image over the entire range is produced.

The lens has a front lens diameter of 3 inches (7.7 cm) and a length of 3.5 inches (8.9 cm). Its smallest aperture is f/22. It weighs less than 20 ounces (560 g) and has an AF on/off switch to allow manual focusing.

Canon EF 20mm f/2.8 USM: This lens is completely different from the old FD-series 20mm f/2.8. It has a 94° angle of view, making it an excellent choice for showing more of a scene or for photographing in close quarters. The lens has a front lens diameter of 3.1 inches (7.75 cm) and a length of 3 inches (7.7 cm). Its smallest aperture is f/22, and it weighs less than 15 ounces (405 g). The minimum focusing distance is 10 inches (25 cm).

Canon EF 24mm f/2.8 and Canon EF 28mm f/2.8: Both of these lens types proved themselves in FD systems and were redesigned for EOS use. Whether the 24mm or the 28mm lens is the more sensible solution is mostly a question of preference.

The 24mm lens exhibits optimal correction at only 12 feet (4 m) because its engineers assumed that the sharpness in the infinity range is mostly a function of depth of field and rarely a result

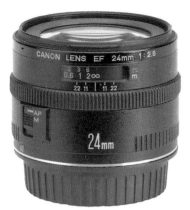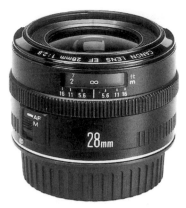

Canon's EF 24mm f/2.8 and EF 28mm f/2.8 lenses are ideal for shooting landscapes, architecture, interiors, and photojournalism.

of direct adjustment. The lens has an image angle of 84°. At its shortest shooting distance, it produces an image size of 7.5 x 11.1 inches (18.5 x 27.7 cm). Because of floating elements, the close-up range of this lens offers high-quality image reproduction down to 10 inches (25 cm). Its focusing speed is 0.44 second from infinity to 10 inches (25 cm). The super-wide-angle lens has a length of about 2 inches (4.85 cm) and weighs only 9.5 ounces (270 g).

The 28mm has five elements in five groups, a minimum aperture of f/22, a filter size of 52mm, and an angle of view of 75°. At 1.7 inches (4.25 cm) long and 6.5 ounces (185 g) in weight, it produces high-quality reproduction down to a distance of 12 inches (30 cm).

Canon EF 28mm f/1.8 USM: This lens has an angle of view of 75° and a floating element design with ten elements in nine groups. It has a minimum aperture of f/22, filter size of 58mm, is 2.2 inches (5.6 cm) long, weighs 10.9 ounces (310 g), and is able to focus down to 10 inches (25 cm).

Normal Lenses

The most obvious advantages to normal lenses are their low weight and lens speed (wide maximum aperture). These lenses have a focal length that corresponds approximately to the size of the film diagonal, which in the 35mm format is about 43mm. Consequently, all the lenses within this class feature focal lengths between about 40mm and 60mm. A standard of 50mm has been preferred since the beginning of the 35mm era because of manufacturing and optical considerations.

Four lenses having a focal length of 50mm are available for the EOS Rebel (EOS 1000 and 500 series) cameras and other EOS models, but only three are so-called "normal" lenses. The fourth is a macro lens with a particularly large close-up range (described in the section "Macro Lenses" in this chapter, p. 146).

All four lenses have an angle of view of 46° across the diagonal. Image effects achieved with these lenses correspond more or less to the way the human eye sees the world. Even though zoom lenses within the normal lens range are used more and more frequently in place of fixed focal length lenses, fixed lenses still continue to be important.

Canon EF 50mm f/1.0 L USM: Currently, this is the only autofocus standard 50mm focal length lens with a photographer's dream aperture of f/1.0. Its optical system includes two aspherical elements and special elements made of ultra-low-dispersion (UD) glass with a high index of refraction. The main advantage of this optical system is high-quality optics with a very large aperture. The lens is one stop faster than the 50mm f/1.4 lens.

The lens focuses down to 24 inches (60 cm). When shooting objects at a distance—a street scene, for instance—the lens' focusing range can be limited. This allows the system to focus more rapidly in a shorter, usable range. Focusing the long distance from infinity to 24 inches (60 cm) takes exactly one second.

A maximum aperture of f/1.0 certainly is not a requirement for everybody, but those who shoot subjects in difficult lighting conditions will be aided by this lens. The depth of field with an aperture of f/1.0 and a shooting distance of exactly 24 inches (60 cm) begins at 23.4 inches (59.5 cm) and ends at 23.7 inches (59.4 cm).

The lens system consists of 11 elements in nine groups, having

The EF 50mm f/1.0 L is an unusually fast specialty lens designed for low-light photography.

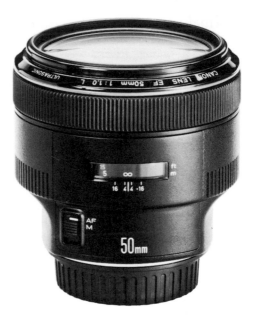

a total weight of just over 35 ounces (985 g). The lens has a length of 3.2 inches (8.1 cm), a maximum diameter of 3.6 inches (9.1 cm), and a filter size of 72mm. The smallest subject area (reproduction ratio 1:11) is 8.9 x 13.4 inches (22.8 x 34.2 cm).

Canon EF 50mm f/1.4 USM: With a maximum aperture of f/1.4, this lens is a half stop faster than the 50mm f/1.8 lens. It is well suited for taking pictures at the theater or circus, as well as in museums, churches, or other places with low light; with high-speed film, in fact, there may not even be a need for flash. This lens, which provides a very bright viewfinder image, high resolution, high contrast, and excellent color balance, has capabilities not even remotely met by many standard zoom lenses, and its performance is exceptional, even at full aperture.

Comprised of seven elements in six groups, and with a close-up limit of 18 inches (45 cm), the lens has a length of 2.9 inches (7.4 cm) and weighs only 10.1 ounces (290 g). Thanks to its Micro USM, this lens can focus extremely quickly, making practically no sound. It also allows manual adjustment without deactivating the AF function.

Canon EF 50mm f/1.8 II: The difference in maximum aperture between a small zoom lens and this fixed lens is almost two stops—a significant difference between the EF 50mm f/1.8 and zoom lenses with this focal length! This normal lens focuses as close as 18 inches (45 cm) and covers a reproduction scale of 1:15.

The optical system consists of six elements in five groups. The lens has a DC Micro Motor for automatic focus and can be focused manually as well. The drive speed from infinity to its closest focusing distance, 18 inches (45 cm), is 0.27 second; the lens can be closed to an aperture of f/22; and the filter diameter is 52mm. The front ring does not rotate during focusing, which is important when using polarizing and special-effect filters. The standard lens has a length of only 1.6 inches (4.1 cm) and weighs under 5 ounces (130 g).

Short Telephoto Lenses

Short telephoto lenses, those in the general range from 70mm up to about 150mm, are often called portrait lenses. Giving them such a label is unnecessarily limiting, though, as they are useful for a large number of subjects other than portraits. The EOS line currently boasts five fixed lenses that fit into this range, and 16 zoom lenses! You certainly have plenty to choose from here.

Short telephoto lenses are particularly suited to portraits from the range of about 70mm up to about 150mm, because they both force the photographer to think in terms of head-and-shoulders shots, and provide a very undistorted and flattering perspective for the portrait subject. Ideal working distance is maintained ranging from about 3 feet (1 m) at one extreme to about 12 feet (3.7 m) at the other.

Typically, these lenses are used for portraiture at wide apertures to throw backgrounds and foregrounds out of focus and place all emphasis on the subject. You should never let this labeling of short telephotos as portrait lenses persuade you, however, not to use other lenses for portraits. I (Bob Shell) have often taken portrait photos with lenses in the 180mm to 200mm range, and know a professional glamour photographer in New York who normally takes head-and-shoulders portraits with 300mm and 400mm lenses because he likes the perspective better; his photos

Canon EF 85mm f/1.2 L USM

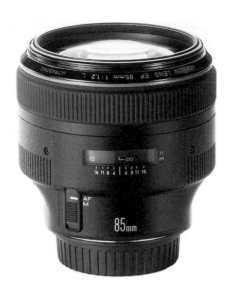

grace the covers of major magazines around the world, so others must agree. I have been in his studio during a session, and he is so far away from the model that he has to shout directions to her!

The point is that there are really no rules on which lens to use, only general guidelines. If a particular lens works for you for a particular picture, then it is the correct lens. What really matters behind all of this technical information about cameras and lenses is the final image. Ultimately, that is all that the viewer sees or cares about.

Canon EF 85mm f/1.2 L USM: This ultra-fast telephoto lens has a length of just 3.3 inches (8.4 cm), a diameter of 3.6 inches (9.15 cm), and weighs 36 ounces (1025 g). Together with the Rebel 2000, this lens fits nicely in the hand, allowing any photojournalist to shoot at 1/30 second with a wide aperture and without a tripod. The ultrasonic motor makes almost no sound. The viewfinder image appears extremely bright due to the lens' high speed of f/1.2. This lens will become the personal standard lens for many quality fanatics.

An aspherical element assures that the aperture of f/1.2 will not be a novelty, but will truly deliver the professional quality

expected. Considering its characteristics, this lens will be cherished by many photographers. Although it belongs to the family of lenses with long focal lengths, it does not compress the linear perspective and does not cause conspicuous spatial restriction. It is most suitable for normal-perspective shots and offers the additional advantage of a slightly smaller imaging field (compared with a 50mm focal length). The scale of reproduction is enlarged by a factor of 1.7. This is a very pleasant ratio for portrait, landscape, and action shots. Large apertures allow the photographer to determine the depth of focus precisely, desirable for portrait and landscape shots.

The super-fast portrait telephoto lens system consists of eight elements in seven groups, including an aspherical lens. The design uses additional floating elements to ensure high reproduction quality at all shooting distances. The image angle is 28° 30′. The high-speed ultrasonic motor runs the extremely long focusing path from infinity to only 38 inches (95 cm) in just 1.2 seconds. Manual focus is possible at any time. The smallest subject area is 9 x 13.6 inches (22.8 x 34.5 cm).

Canon EF 85mm f/1.8 USM: For those on a more restricted budget, the 85mm f/1.8 USM is much more practical than the 85mm L lens. It delivers excellent quality in both contrast and sharpness

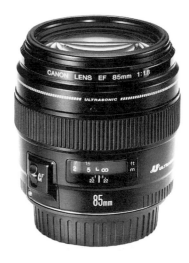

Canon EF 85mm f/1.8 USM

with nine elements in seven groups, a minimum aperture of f/22, a minimum focusing distance of 33.5 inches (85 cm), and an angle of view of 28° 30´. Its filter size is 58mm, its length is 2.9 inches (7.5 cm), and it weighs 14.9 ounces (425 g)—in all, very similar to the EF 100mm f/2.0 USM in size, weight, and cost.

Canon EF 100mm f/2.0 USM: The maximum aperture of f/2 can produce high-quality pictures at light levels where photographers with zoom lenses have long since given up. The fastest aperture a zoom lens can deliver at the 100mm focal length is only f/4.5 to f/5.6. This is a difference of 2 to 2-1/2 stops when compared to the 100mm f/2.0. Even after the photographer with a zoom has reached a shutter speed of 1/30 second, comfortable hand-held shots can be taken of the same subject with this lens at 1/200 to 1/180 second. Also, the viewfinder image is brighter by the same factor.

The quality in the close-up range is very high. In addition, this lens offers good image reproduction with a fully open aperture and is ideal for landscapes and portraits; even normal snapshots made in difficult lighting situations can be handled comfortably. The new USM motor, with optional manual adjustment and the internal focusing feature, allows lightning-fast focusing over the entire range within 0.4 second. The image angle is 24°.

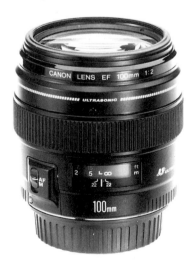

Canon EF 100mm f/2.0 USM

The eight lens elements in five groups assure sharpness. The lens barrel does not change in length during focusing, providing optimum balance, and a photographer using a polarizing filter will welcome the fact that the front ring does not turn during focusing. At a length of 2.9 inches (7.35 cm), a weight of 16.1 ounces (460 g), and a size of 56mm, the lens fits comfortably in the hand. The lens hood (ET-65II) should always be attached.

Canon EF 200mm f/2.8 L USM: This high-speed telephoto lens, which incorporates three elements of UD ultra-low-dispersion (UD) glass and the USM motor system, has been a favorite of photojournalists when they need a very fast lens of this focal length. The manual focus ring has three settings to adjust the tension, and the AF provides three focusing ranges: 8.2 feet (2.5 m) to infinity, 16.4 feet (5 m) to infinity, and 8.2 feet to 16.4 feet; in addition, the lens has a focus memory that allows instant return to a preset focus by activating the preset focus switch.

The EF 200mm f/2.8 L USM lens is composed of 12 elements in 10 groups, and has a 12° angle of view and a minimum focusing distance of 8.2 feet (2.5 m). It is 8.2 inches (20.8 cm) long, 5.1 inches (10.3 cm) in diameter, and weighs 6.6 pounds (3 kg); its drop-in filter size is 48mm.

Canon EF 200mm f/2.8 L II USM: The advantages offered by this high-speed telephoto lens are selective sharpness and sharp focus; the close-up limit is 4.9 feet (1.5 m). The lens system consists of nine elements in seven groups, with two lenses consisting of UD glass exhibiting anomalous dispersion characteristics. These lenses reduce color errors and ensure high-contrast sharpness. The lens' 12° angle of view offers an impressive perspective, in the close-up range in particular. The lens has a length of 5.4 inches (13.6 cm) and weighs 1.7 pounds (0.8 kg).

It would be a pity not to use this lens with a Canon Extender (1.4x or 2x) to make it an AF USM lens featuring values of 280mm f/4 or 400mm f/5.6. In both cases, the close-up limit is 4.9 feet (1.5 m).

Telephoto lenses work well for shooting architectural images with normal perspective and minimum convergence of vertical lines.

Super Telephoto Lenses

Canon EF 300mm f/4.0 L USM: This lens is a less expensive alternative to the EF 300mm f/2.8 L. In many respects, it is comparable to the EF 200mm f/2.8 L. Its exterior is similar to the large, gray super lenses, and rightfully so, because it carries the L in its name and hence may be considered to be Canon lens nobility. It has two UD glass elements, which reduce imaging errors to a minimum. Canon EF 1.4x and 2x extenders can be used, making it into a 420mm f/5.6 or 600mm f/8 lens, respectively. Autofocus is possible when the 1.4x extender is used with this lens; if used with the 2x extender, however, the lens must be focused manually.

The close-up shooting distance is 8.2 feet (2.5 m), resulting in a scale of reproduction of 1:7.7. Nine elements in seven groups make up the lens, giving it a length of 8.37 inches (21.3 cm) and a diameter of 3.6 inches (9.1 cm), covering an angle of view of 8° 15´. Its image sharpness and excellent contrast are impressive.

More recently, a new version of this lens, integrating Canon's remarkable IS technology, has been introduced.

Canon EF 300mm f/4.0 L USM

Canon EF 400mm f/5.6 L USM

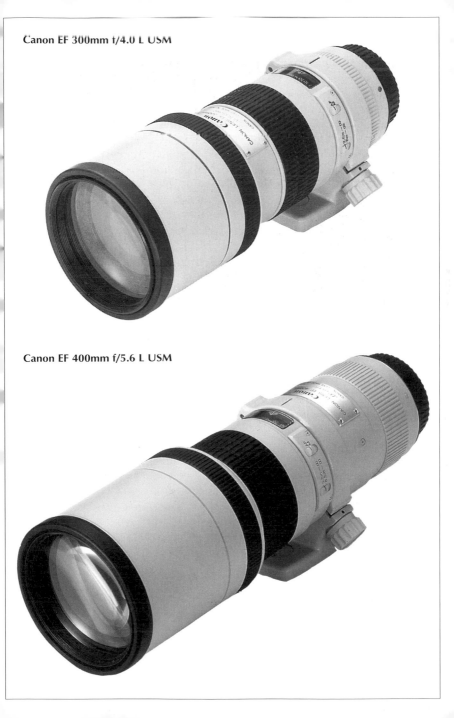

Canon EF 400mm f/5.6 L USM: This super telephoto is the alternative to the 400mm f/2.8 L II USM lens, which costs considerably more. Two low-dispersion UD elements minimize chromatic aberration. For the first time, a newly developed type of glass was used that exhibits even less light scatter, as well as characteristics that are normally achieved only by using sensitive fluorite crystals.

The fastest AF setting of this lens' M-1 USM covers two focal ranges. For shorter focusing times, the photographer can restrict the distance range from 11.5 feet (3.5 m) to infinity to 27.9 feet (8.5 m) to infinity. An extender can be used, but the focus must be set manually to accommodate the small maximum aperture.

The lens has a length of 10.1 inches (25.6 cm), a filter size of 77mm, and a weight of 2.7 pounds (1.25 kg), making it a lightweight in its class. Even though the tripod mount can be removed for hand-held shots, the use of a tripod (or at least a monopod) is recommended whenever this lens is used.

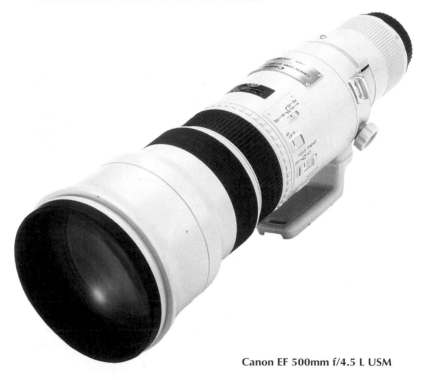

Canon EF 500mm f/4.5 L USM

Canon EF 500mm f/4.5 L USM: This powerful telephoto lens is particularly lightweight and compact. Despite its large maximum aperture of f/4.5, its weight could be maintained at 6.6 pounds (3 kg)—keeping its weight much lower than the EF 400mm f/2.8 L II USM. By using lenses of synthetic crystalline fluorite and glass exhibiting an extremely low index of refraction, residual chromatic aberration errors have been almost eliminated. In addition, both sharpness and color reproduction have been improved significantly. The ultrasonic drive, along with the internal focusing system, ensures fast focusing; its minimum focusing distance is 16.4 feet (5 m). A filter drawer holds 48mm filters; gelatin filters with filter holders can also be used. The lens has a length of 15.4 inches (39 cm) and a maximum diameter of 5.2 inches (13.2 cm). The optical system consists of seven elements in six groups.

Large-Aperture Telephoto Giants

Canon's powerful giants for professional applications are the optical treats of the EF interchangeable lens program. They are immediately recognizable because of their entirely atypical light gray color. All of them have a large metal lens hood, a stable foot with a rotating mechanism and tripod thread mount, and loops for a carrying strap. The smallest weighs 6.3 pounds (2.9 kg), the largest (1200mm f/5.6 L USM), 36.3 pounds (16.5 kg). Even though they all belong to one family, each lens has its own special features. Altogether, they are dream lenses for anyone whose job requires work with such long focal lengths and for those who simply want to indulge themselves.

Fluorite and UD lenses ensure top ratings for contrast and resolution. These special lenses are easy to handle, and all of them allow the photographer to store a preset shooting distance. It does not matter how many times other distances have been measured—a slight turn of the focusing ring and the lens is reset to the stored value. (The presetting mechanism has an optional, audible confirmation signal.) Sports photographers will really appreciate this distance preset feature. In fractions of a second, faster than the camera can be redirected at the subject, the photographer can continue to take pictures in the second preset distance range.

The ultrasonic motor offers electronic support for manual focusing. When the focusing ring is rotated, electrical pulses are generated, which signals to the lens' microprocessor that the ultrasonic motor should run. In this way, manual focusing causes almost no vibrations. All of these lenses feature adjustable manual focusing speeds (low, medium, and high) to suit the subject. They also offer the photographer the option of adapting the manual adjustment to his or her liking. Step 1 (low) offers half the rate of rotation, which is very useful for portraits or subjects in the close-up range and wherever very precise adjustment is important. Step 2 (medium) uses the normal rate of rotation, and Step 3 (high) uses double the rate of rotation, as is frequently required in sports photography.

The telephoto lens' focusing paths are normally relatively long; therefore, these four Canon lenses, described below, have preset focusing ranges to shorten the adjustment process whenever possible. A slip-in filter mount permits the use of filters with these lenses. Normal Canon screw-mount filters in 48mm size, or even a circular polarizing filter of the same size, can be attached. A special gel filter holder accessory is available. Because all lenses are apochromatically corrected, they do not require refocusing when used with infrared film.

The use of a tripod with these lenses is absolutely essential to receive the best quality image. A stable monopod is recommended if more camera mobility is required, as when taking sports shots.

Canon EF 300mm f/2.8 L USM: As far as the optics are concerned, this lens is the successor of the FD 300mm f/2.8 L, which has many devotees among sports photographers. The AF model was the world's first lens with the USM drive, and still the star today at football stadiums and playing fields. Many professionals consider this lens the standard in terms of quality, speed, and price. Because the quiet USM drive does the focusing, this lens is as suitable for stage and theater photographers as it is for wildlife, landscape, sports, and press photographers. It is great as well for big-time media events, when photographers could be exiled to ditches or behind barriers. With the Canon extenders, focal lengths of 420mm or 600mm at f/4 or f/5.6 are achieved. This lens produces a 6x magnification and, in combination with

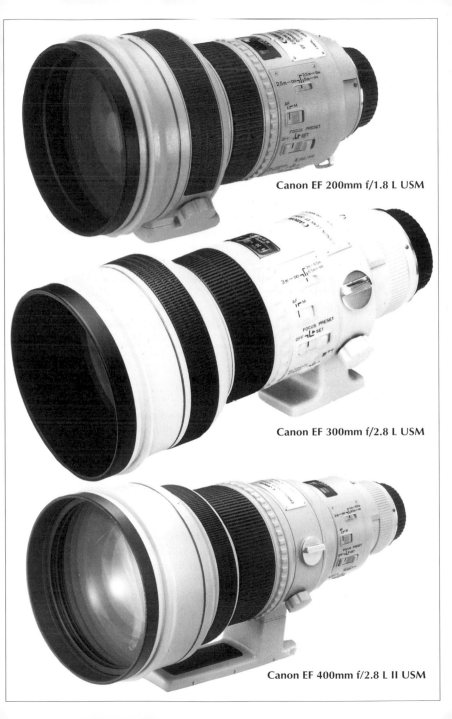

Canon EF 200mm f/1.8 L USM

Canon EF 300mm f/2.8 L USM

Canon EF 400mm f/2.8 L II USM

extenders, an 8.5x or 12x magnification compared to a 50mm normal lens. One calcium fluorite element and one UD glass element provide optical correction for unsurpassed sharpness at great distances, along with exceptional color saturation.

Canon EF 400mm f/2.8 L II USM: In 1980, when Canon introduced the first FD 400mm f/2.8 lens, it became the immediate rage among sports photographers. Now this autofocus 400mm lens shines as the current star. The entire focusing range from infinity to 13.2 feet (4 m) can be run in only 0.7 second. Two UD glass elements ensure professional sharpness, as expected from this L-series lens. Extenders make it into a 560mm f/4.0 or a 800mm f/5.6. At a length of barely 14 inches (35 cm), it is surprisingly compact and exceptionally suitable for all subjects, including landscape, sports, action, and wildlife photography.

The optical system consists of 11 elements in nine groups. The diagonal image angle is 6° 10′; rapid internal focusing is ensured by the USM drive. The lens weighs 13 pounds (5.9 kg) and has a length of 13.7 inches (34.8 cm). Its largest diameter is 6.6 inches (16.7 cm).

Canon EF 600mm f/4.0 L USM: Wildlife, sports, and fashion photographers use this lens regularly. Two UD glass elements with anomalous partial dispersion and a calcium fluorite element with a large diameter were required to eliminate the secondary spectrum, allowing this lens to equal other L-series lenses in its quality and performance.

A 1.4x extender makes the 600mm f/4.0 lens into a 800mm f/5.6 lens. By using the 2x extender, it is possible to convert this lens into a 1200mm f/8 super-telephoto lens—which, however, must be focused manually. Other than that, rapid focusing is ensured by the USM drive and the rear-component focusing system. A focus-preset function allows a lightning-fast change to a preselected focal setting. The manual focusing ring has a motor-assist device.

The optical system consists of nine elements in eight groups. The image angle is 4° 10′ and the shortest shooting distance is at 19.7 feet (6 m). The super telephoto lens weighs 13.2 pounds (6 kg), has a length of 18 inches (45.6 cm), and a maximum diameter of 6.6 inches (16.7 cm).

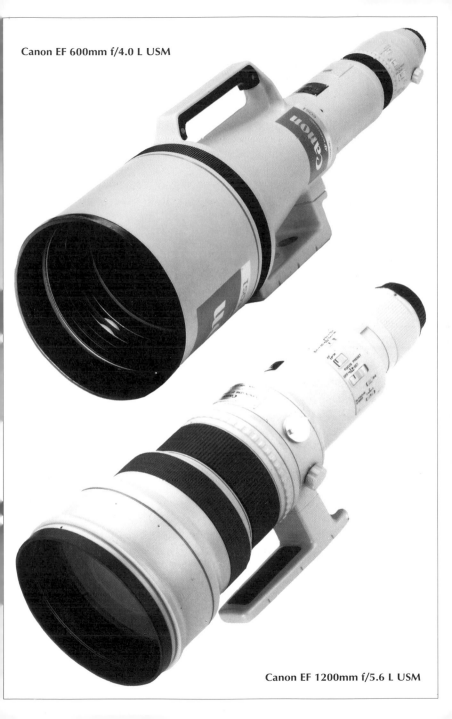

Canon EF 600mm f/4.0 L USM

Canon EF 1200mm f/5.6 L USM

Canon EF 1200 f/5.6 L USM: This lens, manufactured only by special order, has the greatest focal length of any autofocus lens, and a price to match. As you can imagine, they aren't purchased often; they can be rented by accredited press photographers at large sports events. The data on this lens is quite impressive. Its optical system consists of 13 elements in ten groups. Two fluorite lenses eliminate chromatic aberration and ensure a sharp image at maximum aperture.

Three focal ranges can be preselected for the shortest focusing periods, aided by the fast and super-quiet ultrasonic motor. Considering an image field of 10.8 x 16.3 inches (27.5 x 41.3 cm), the first range covers from 46 feet (14 m) to 98.4 feet (30 m). The second full focal range covers 46 feet (14 m) to infinity, and the third from 98.4 feet (30 m) to infinity. The lens has a length of 33 inches (83.8 cm), a weight of 36.3 pounds (16.5 kg), and a diameter of 9.2 inches (23.4 cm). The lens barrel, with a diameter of 48mm, is designed to hold insertable filters. A handle allows a quick switch between landscape and portrait formats.

It is even possible to use Canon extenders on this monster lens. An EF 1.4x makes this lens into a 1700mm f/8 super-telephoto lens, and an EF 2x into a 2400mm f/11 lens—allowing shots of details of the moon. The maximum aperture, f/11, requires manual focus.

Zoom Lenses

There are many photographers who simply refuse to use zoom lenses at all because they cling to the prejudice that zoom lenses do not produce sharp images. Zoom lenses got this reputation in their early days, and the first zoom lenses, such as the Voigtlander Zoomar, were pretty bad by any standard. But that was many years ago, and much technological progress has been made during those years. Early on, Canon discovered a relatively simple design principle for zoom lenses. This is why inexpensive zoom lenses that exhibit high quality and retain a small size are now available. Today, we have high-quality zoom lenses that give very little away to fixed focal length lenses.

As do fixed focal length lenses, zoom lenses have their advantages, and most well-equipped photographers will have some of

both types for use in different circumstances. For example, even though I (Bob Shell) usually use the 28-80mm f/2.8-4.0 L USM zoom, I also have the 85mm f/1.8 USM. Why? Because at the 80mm end of its zoom range, the 28-80 becomes f/4.0, and that is not fast enough for some purposes. Also, it does not allow me to set a really shallow depth of field, as I can easily do with the 85mm by simply setting it to f/1.8 or so. For a similar reason, I also have a 50mm f/1.8, although I do not use it very much. But when you need it, nothing else will do. (Some of the lenses mentioned in this paragraph may have been discontinued.)

When taking photos with a zoom lens, we recommend that you adjust it first to its greatest focal length. As soon as the camera is placed up to your eye and the viewfinder image is in focus, the best possible image has usually been achieved. Candids are optimally shot right away; then, the image angle can be changed to determine whether the image might be framed better. A better frame happens relatively rarely, however, and if it does it's frequently at the other end of the focal length range. When you shorten the focal length, the distance setting is changed only in rare cases; this happens more frequently when you work the other way around.

In many situations, for example when you're going on a trip or whenever you do not want to carry additional lenses, a focal length range of 35mm to 105mm—or even 135mm—is ideal. This means that not only can you shoot subjects at the desired reproduction scale with a single lens, but you can also be creative with the focal length.

The wide-angle range offers a more panoramic view of a landscape, allows a large group of people to be in one picture, and helps solve restrictive or crowded spatial conditions in indoor shots.

The focal length range, between 80mm and 100mm, is ideal for taking photos of people and snapshots at parties and sporting events. Wide angles used to take landscapes produce pictures that exhibit a more neutral perspective; due to their slight telephoto effect, however, they ensure that the selected image frame does not appear overloaded. All in all, this is a universal focal length range.

Almost all zoom lenses have a so-called "macro" (close-up) setting. This setting is no substitute, however, for a macro lens, which is designed especially for extreme close-up work. A zoom

Page 129
Use a wide-angle lens and set a small aperture to render the entire scene in sharp focus from foreground to background.

Page 130
The Rebel series' Portrait mode is ideal for taking full-face portraits; Landscape mode is ideal for scenics. A wide-angle to telephoto zoom such as the Canon EF 28-105mm f/3.5-4.5 USM lens is extremely versatile, allowing you to take photos of a variety of subjects without changing lenses.

Page 131
With a telephoto zoom, the Rebel series can be set to Full Auto or Close-Up mode to produce good exposure for wide views (above) or extreme close-ups (below).

Page 132
Above: A 200mm telephoto lens was used in this photo to compress the distance between the boat and the buildings in the background.

Below: The Rebel 2000's 35-zone evaluative metering system produced good exposures, even with the glare of the late-day sun.

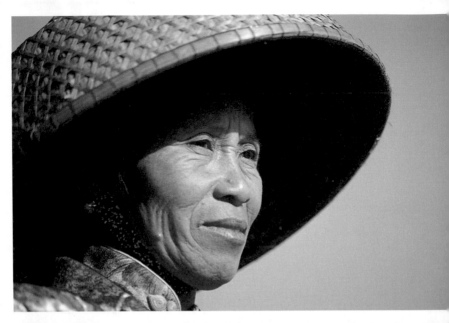

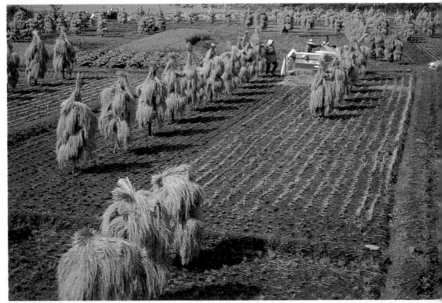

Page 133
Neither the white cupola against the blue sky nor the fire hydrant against the dark bricks posed a problem for the Rebel 2000's evaluative metering system.

Page 134
The Rebel series' Portrait mode makes photographing people easy. Just compose the image and shoot!

Page 135
A telephoto zoom lets you capture detail without getting too close to the subject. To render extreme detail, it is best to use a small aperture.

Page 136
Canon L series lenses deliver the highest quality reproduction, valuable when fine detail is a factor.

lens' macro setting relies on the sharpness it achieves at the center of the lens, and therefore requires that you set a small aperture to obtain sufficient depth of field. The apparently reduced distance setting represents the actual working range of the lens and should always be set just to prevent unnecessary focusing adjustments. The shortest focusing distance setting for any zoom lens is the lens' macro setting, and the normal autofocus range is from that value to infinity.

Canon EF 20-35mm f/3.5-4.5 USM: For years, Canon has offered a professional-quality lens using this focal length range. The 20-35mm super-wide-angle zoom lens, with a maximum aperture of f/3.5 to 4.5, is a surprisingly good-quality lens at an affordable price.

Distortions may become a problem, in particular in the super-wide-angle zoom range. By consistently using spherical elements, Canon has significantly minimized these difficulties and achieved high resolution with only insignificant distortions along the image edges. In addition, a type of diaphragm blocks flare, which would ordinarily impair contrast.

The minimum shooting distance is 13.5 inches (34 cm). The lens system consists of 12 elements in 11 groups and features internal focusing. The front lens does not rotate, and filters with a diameter of 77mm as well as polarizing filters can be used in the super-wide-angle range. As is the case with other lenses, a lens hood (EW-83) should be used at all times (see accessories chapter).

Canon EF 22-55mm f/4-5.6 USM: This new lens is an unusual focal length range, going from very wide to normal. It uses nine elements in nine groups, one element a replica aspheric. The lens focuses down to 13.7 inches (34 cm), accepts 58mm filters, and measures 2.6 x 2.3 inches (6.6 x 5.94 cm). This lens is also very light at only 6.2 ounces (175 g).

Canon EF 24-85mm f/3.5-4.5 USM: This versatile lens offers the photographer a wide range of focal lengths, from wide-angle to short telephoto. Its ring-type USM delivers nearly silent operation and quick AF response. The lens features on-demand manual focus; there is no M/AF switch. It close-focuses to 19.6 inches (50 cm), has 15 elements in 12 groups, is 2.87 inches (6.9 cm) long, and weighs 13.3 ounces (380 g).

Canon EF 28-80mm f/3.5-5.6 V USM: This lens, which has become the new standard lens in the zoom range, illustrates Canon's revised basic conception of the EOS system. Improved USM technology and the development of a micro USM for mass production integrate the advantages of this AF drive system in less expensive EF lenses. The 28-80mm lens features lead-free glass elements and a fixed auxiliary diaphragm (a baffle) between the second and third zooming groups, which acts to suppress flare throughout the entire focal length range. All of these features ensure that this zoom lens provides surprising quality at a favorable price.

This lens is installed in such a way that the use of the Rebel 2000's built-in flash unit does not produce shadows caused by the lens edge; the length of the lens does not prevent full use from being made of the flash unit, even at a shooting distance of 3 feet (1 m).

The optical system, which consists of ten elements in ten groups, can focus as close as 15 inches (38 cm). It has a length of 2.8 inches (7.1 cm) and a maximum diameter of 2.6 inches (6.6 cm). Depending on the set focal length, the smallest aperture varies from f/22 to f/38. The filter size is 58mm. This zoom lens weighs 7.1 ounces (200 g).

Canon EF 28-80mm f/3.5-5.6: This lens is similar to the more expensive 28-80mm USM version. With its DC Micro Motor, however, it is a touch slower and not quite as quiet. These concessions, though, do not affect the quality of picture it takes and are worth the savings to the cost-conscious photographer.

Canon EF 28-105mm f/3.5-4.5 USM: This is an excellent zoom with highly corrected optics and a wide range of focal lengths. It is even smaller and lighter than the 35-135mm, making it a favorite among Canon users. It has 15 elements in 12 groups, an angle of view of 75° to 23° 20′, a filter size of 58mm, and a minimum focusing distance of 19 inches (50 cm); is 2.8 inches (7.2 cm) long, and weighs 13.1 ounces (375 g).

Canon EF 28-135mm f/3.5-5.6 IS USM: This lens quickly became a favorite of mine (Bob Shell) for its very useful focal length range and the implementation of IS technology, which frees me from a tripod or monopod when working outdoors in almost any light. I

consider this just about the ideal lens for the great majority of my photography work, both in the studio and outdoors. While it is not an L-series lens and therefore not as highly corrected as the 28-80mm L that I used for so many years, the gain of IS technology more than makes up for any slight loss in image quality, and the number of blurred images I get due to camera motion is minuscule with the new lens. The lens uses 16 elements in 12 groups, with one glass molded aspheric element. The lens focuses as close as 19.7 inches (50 cm), close enough for most applications other than true macro. The lens accepts 72mm filters and measures 3.8 x 3.1 inches (9.68 x 7.84 cm); its weight is 17.6 ounces (500 g). Unfortunately, it's been discontinued; it's worth trying to find.

Telephoto Zoom Lenses

Until recently, heated debates among proponents and opponents of zoom lenses still raged. Numerous quality improvements on lenses with variable focal lengths have reduced the problem to the question of maximum aperture (speed) versus convenience. Fixed focal lengths will always be available to solve special problems, but a user-friendly zoom lens is quite welcome even in professional circles. The advantage of framing a subject in an ideal manner without changing camera position is tempting. Many photographers, however, forget that the relationship between foreground and background changes dramatically when you consider a distance of 60 feet (20 m) at a focal length of 200mm or a distance of 24 feet (8 m) at a focal length of 80mm. This is not obvious based on the main subject, but based instead on the size and sharpness of objects at different distances in the background.

Many photographers, as well, think and see in focal lengths; they have a 50mm, 100mm, and 200mm view stored in their heads. They know from the very beginning how the picture will look and how to represent the foreground relative to the background. A zoom lens makes this learning process more difficult, but it opens up creative possibilities, such as the so-called zoom effect, a radial blur.

The decision of what lens to buy depends on different requirements. The easiest criterion would be to focus on the Luxury (L)

series. A professional certainly will look at the L lenses with careful consideration, whereas an amateur photographer will probably make a decision based more on a budget. Canon's 35-350mm L super zoom is certainly interesting to those who want to get along with the smallest number of lenses.

A decision on the focal length range is more difficult. Because it is convenient, the focal length range from 80mm to 200mm has become the most popular. By going with an 80-200mm f/4.5-5.6 II and a wide-angle zoom lens, such as the 28-80mm f/3.5-5.6, the entire range from 28mm to 200mm can be covered with just two lenses.

The close-up range of the 80-200mm lens set at 200mm at 4.9 feet (1.5 m) allows the capture of a butterfly at a convincing size because at 200mm the size of the subject area is 5.2 x 7.9 inches (13.3 x 20 cm). A special macro setting and a distance of 3.6 feet (1.2 m) provides a subject area that at 200mm is not much bigger than a postcard, and at 50mm is still approximately 16 x 24 inches (40 x 60 cm). And remember, a wide aperture should not be used with a macro setting. A reduction by at least two f/stops from wide open is recommended. The type of macro setting on telephoto zoom lenses is a technical by-product of the lens design and can also be used in autofocus mode.

Most of Canon's tele-zoom lenses are of reasonable weight, ranging from 8.8 ounces (250 g) of the 80-200mm f/4.5-5.6 II to 1.5 pounds (695 g) of the 100-300mm f/5.6 L. Only the 35-350mm f/3.5-5.6 L USM and 70-200mm f/2.8 L USM are heavier, weighing 3 pounds (1.385 g) and 2.7 pounds (1.275 g) respectively.

The tele-zooms are convenient to carry and easy to handle. The only disadvantage is their relatively small maximum aperture, based on the viewpoint of photographers who like to emphasize the particularly photogenic boundaries of light. Considering a focal length of 35mm, the f/3.5 maximum lens aperture is not exactly overwhelming, and considering a focal length of 350mm, an f/5.6 maximum lens aperture is barely adequate; an exception is the Canon Zoom FF 70-200mm f/2.8 L USM. Those who have a normal lens (like the 50mm f/1.8 II) and want to stay at a reasonable cost should consider either the 75-300mm f/4.0-5.6 II or the 75-300mm f/4.0-5.6 III USM.

A photographer who is not afraid to set up a tripod once in a while and has the time and patience will find the EF 100-300mm

f/4.5-5.6 USM an ideal lens. Even the close-up setting of 4.9 feet (1.5 m) with a six-times-larger scale of reproduction is convincing compared with a normal lens. The L version of the 100-300 features an overall upgrade in quality with an additional UD lens and apochromatic correction. The 70-210mm and both 100-300mm zoom lenses have a so-called macro setting, which has only minimal differences in the scale of reproduction. With the shortest focal length setting, the subject is somewhat larger than a piece of letter-size paper; with the longest setting, it is somewhat smaller.

Canon EF 35-350mm f/3.5-5.6 L USM: This super-zoom lens, which covers the largest focal length range of all the Canon zoom lenses, ranges from wide angle all the way to super telephoto. This was achieved by a separate adjustment microprocessor in the lens and a multiple group design comprised of five lens

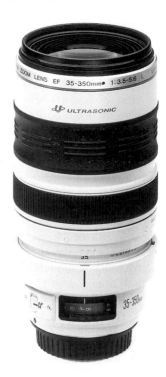

Canon EF 35-350mm f/3.5-5.6 L USM

groups, all of which move when the focal length is changed. The movements of each group, however, are very short because each lens group exhibits an optimal index of refraction. Focusing takes place through a rear component focusing system, run smoothly and rapidly by an ultrasonic motor, that allows sharp focusing in the wide-angle range down to 24 inches (60 cm). In the greater telephoto range, the close-up limit is 6.6 feet (2.2 m). This allows the smallest imaging field of 6.1 x 9.7 inches (15.5 x 24.7 cm).

Two UD glass elements reduce chromatic aberration and ensure sharp reproduction over the entire range. The lens, which is surprisingly compact, has a length of less than 7 inches (17 cm), weighs 3 pounds (1.385 kg), and can even be used for hand-held shots if supported with a rifle stock or hand grip.

Canon EF 75-300mm f/4.0-5.6 II USM: This zoom lens allows an inexpensive beginning into the telephoto realm. Its low weight is 17.3 ounces (495 g), 9% lighter than the EF 100-300mm f/4.5-5.6 USM. At a length of 4.8 inches (12 cm), it can be used quite comfortably for hand-held shots. The optical system consists of 13 elements in nine groups; the shortest focusing distance is 4.9 feet (1.5 m). It also comes in a slightly lighter weight DC Micro Motor model.

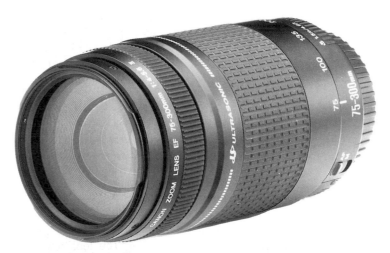

Canon EF 75-300mm f/4.0-5.6 II USM

Canon EF 75-300mm f/4.0-5.6 IS USM

Canon EF 75-300mm f/4.0-5.6 IS USM: With this lens, Canon has made the world's first SLR interchangeable lens with image stabilization (IS). This combination of optical and electronic technology compensates for camera and lens movement, allowing you to shoot hand held at slower shutter speeds (up to 2 stops!). The lens has 15 elements in ten groups, a minimum focusing distance of 4.9 feet (1.5 m), and a filter size of 58mm. This lens is 5.4 inches (13.7 cm) long and weighs 23.5 ounces (670 g).

Canon EF 100-300mm f/4.5-5.6 USM: This is a very compact lens offering exceptionally fast autofocusing from its newly designed optical system, with only three inner moving elements. The complete optical construction consists of 13 elements in ten groups. The size of the lens is 4.75 inches (12.1 cm) long, with a maximum diameter of 2.9 inches (7.3 cm). The weight is 19 ounces (540 g), and the angle of view covered by this zoom lens is 24° to 8° 15´.

Canon EF 100-400mm f/4.5-5.6 IS L USM: This new Canon EF lens offers the extremely versatile range of 100-400mm, an ideal range for sports, wildlife, and many other types of telephoto photography. The lens speed of f/4.6-5.6 may not seem all that fast, but this is more than made up for by the use of IS technology, which permits this lens to be used hand held even at slow shutter speeds. Because it is from Canon's L series, this is a fully professional lens of the highest optical quality. The optical formula consists of 17 elements in 14 groups and includes one each of fluorite and Super UD glass. Filter size is 77 mm. The lens measures 7.4 x 3.6 inches (1.89 x 9.2 cm) and weighs 3 pounds (1.385 kg).

Canon EF 100-300mm
f/4.5-5.6 USM

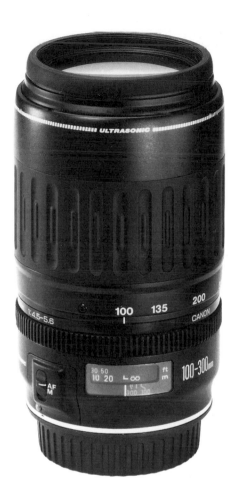

Canon Extenders EF 1.4x and EF 2x

Extenders are optical accessories that are placed between the camera and the lens to extend the effective focal length of the main lens. The numbers 1.4x and 2x indicate the factor by which the lens' focal length is increased. This focal length extension produces a reduction of speed (or effective aperture). In the case of the Extender EF 1.4x, this is one stop, and in the case of the

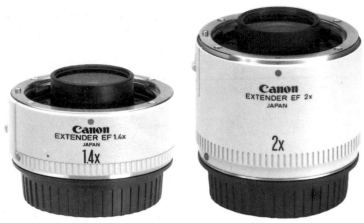

Canon makes two EF extenders, the 1.4x and the 2x.

EF 2x, two stops. All functions governing aperture and autofocus control are maintained. If the aperture of the lens attached to the converter is less than f/5.6, however, the autofocus system won't function properly, and the lens must be focused manually.

Although some aftermarket extenders or teleconverters have inexpensive, low-quality optics, Canon converters are high-quality lens systems specifically designed for use with Canon telephoto lenses. They can be expensive, but they add tremendous versatility to a lens outfit.

Macro Lenses

Canon EF 50mm f/2.5 Compact Macro: Macro lenses are designed for flat-field reproduction and high performance in the close-distance range. The 50mm macro features particularly high resolution, excellent contrast, and optimal image-area flatness. The minimum focusing distance is 9.1 inches (23 cm); at this point, a subject is recorded at half its original size (a 1:2 reproduction ratio) on the film.

When pictures are taken of flowers, insects, or other small subjects in nature, the Aperture-Priority (Av) and Auto Depth-of-Field (A-DEP) modes come in handy. Using these features, however,

will not eliminate the problem of shallow depth of field (which is barely 6 mm at f/11 and a scale of reproduction of 1:2). This effect is inherent in close-up photography, but with proper technique, it can be reduced to an acceptable degree. For example, flowers can be framed so that the largest part of the blossom is parallel to the film plane and depth of field is not a critical factor in the final outcome of the photo. The same applies when photographing a subject such as a beetle. It is best photographed directly from the top or the side, so that the largest area of its body is parallel to the film plane. Also, as with all close-up work, use of a tripod is recommended.

Canon offers the EF Life Size Converter as an accessory for use with this lens. This converter, which is mounted between camera body and lens, permits shots at a scale of reproduction between 1:4 and 1:1 and compensates for the spherical aberration in the close-up and macro ranges.

The EF 50mm f/2.5 compact macro is also suitable as a universal lens in all shooting ranges. The AFD motor allows automatic focusing from infinity to a scale of 1:0.5 in only 1.5 seconds. Manual focusing is also possible. The lens has a length of 2.5 inches (6.3 cm) and a weight of 9.9 ounces (280 g).

A 50mm comparison: The EF 50mm f/1.8 (left) vs. the EF 50mm f/2.5 compact micro.

Canon EF 100mm f/2.8 Macro: This fast telephoto lens was designed specifically for macro shots up to a scale of 1:1 without additional intermediate rings or the EF Life Size Converter. A focus-limiting switch permits selection between two distance ranges; one is within the macro range of 12.4 inches (31.5 cm) and 22.8 inches (57.9 cm), and the other goes from 22.8 inches (57.9 cm) to infinity. The autofocus DC Micro Motor covers this distance in exactly 1 second. The smallest subject area is 0.5 x

1.4 inches (1.3 x 3.6 cm). A system of 10 elements in nine groups provides a viewing angle of 24°. The lens has a length of 4.1 inches (10.5 cm) and a weight of 22 ounces (650 g).

Canon EF 180mm f/3.5 L Macro: The latest addition to the Canon macro stable, this lens offers all of the conveniences of the EF 100mm f/2.8 macro but with a longer focal length for those who need more working distance between lens and subject, or a different perspective.

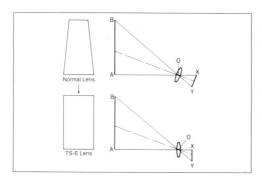

This simple diagram illustrates how a tilt-shift (TS-E) lens eliminates the need to tilt the camera upward when photographing a building, thus eliminating perspective distortion.

Tilt-Shift Lenses

Tilt-shift lenses allow the correction of the notorious converging verticals or distorted parallel lines that form when the film plane and the subject plane are not parallel. This is the case whenever, for example, large buildings are shot and the camera must be tilted upward to capture the entire view. Without this lens, tilting the foreground becomes disproportionately dominant, and only part of the building is in the picture. By shifting a lens out of the optical axis, this view can be adjusted in the desired direction. Rather than simply making perspective control lenses, as other makers have done, Canon has combined this perspective control shift with tilt capability, calling them tilt-shift (TS-E) lenses.

These special Canon EOS lenses come in three focal lengths: TS-E 24mm f/3.5 L, TS-E 45mm f/2.8, and TS-E 90mm f/2.8. All three lenses exhibit excellent image quality and ensure maximum contrast, resolving power, and brilliance of color rendition. The TS-E 24mm f/3.5 L lens is equipped with a ground and polished

TS-E 90mm f/2.8 tilt-shift lens

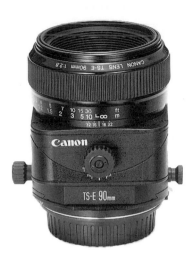

aspherical element, which assures this lens' optical performance is at the same level as the other TS-E lenses, despite its shorter focal length.

All three lenses can be tilted by +/–8°, and the entire optical system can be shifted by +/–11 mm; 4 mm of this scale is marked in red only on the super-wide-angle lens. When tilting is combined with maximum shift, vignetting may occur in this red range.

Filters

Filters, which can be used to enhance or correct the way an image will appear on film, are a relatively inexpensive and enjoyable way to improve and add creative interest to your photographs. Purchasing even a few filters and using them properly can make a big difference in the final outcome of your photographs. Experimenting with the many special-effect filters available from Canon and other manufacturers such as Tiffen® will add hours of enjoyment and can result in many interesting and unusual photos.

Filters are most commonly available in two forms: round filters mounted in threaded rings that screw into the lens barrel; and square or rectangular filters that fit into a filter holder fastened to the front of the lens with a threaded adapter ring. A filter mounted in a threaded ring comes in a specific diameter, which matches the diameter of the lens it can be attached to. You can buy one set of round filters that fit your largest lens, and then equip all smaller-thread lenses with a step-up adapter ring that accommodates this size.

General-Purpose Filters

Polarizing Filters

Polarizing filters can eliminate distracting reflections on non-

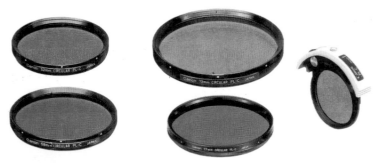

Canon makes circular polarizing filters in a number of sizes.

metallic surfaces such as water, glass, polished stone, wood, or varnished surfaces, as well as dyed surfaces. Also, grasses, plants, and (particularly in southern countries) plants with leather-like leaves not only reflect visible light but also UV radiation, which the film receives as blue light. In these situations, polarizing filters offer warm, spring-like green colors. The effect is strongest at an angle between 30° and 40° in relation to the reflecting surface. Greater focal lengths enhance this effect significantly, and distance views benefit in particular. The result can be controlled based on what is seen in the viewfinder.

Only circular (rather than linear) polarizing filters can be used with the Rebel cameras because of their AF system. Canon offers these filters in six sizes: 48, 52, 58, 67, 72, and 77mm.

The use of a polarizing filter is complicated by zoom lenses with rotating filter mounts. If the filter is adjusted first, its effect is changed when the lens is focused. In this case, focus first, then adjust the polarizer.

Graduated Neutral-Density Filters

Like polarizing filters, neutral-density (ND) filters are a must for landscape photographers because they reduce intense contrasts produced by the sky. Water, sky, snow, sand, or other light-colored surfaces can also be darkened with these filters. Colorless subjects (such as sky) benefit from colorization and darkening. Canon makes two ND filters. The ND4L reduces the light to 1/4 its original intensity (2 stops) and the ND8L reduces it to 1/8 (3 stops). Tiffen also makes many different filters of this type, including color-graduated filters.

Skylight Filters

Skylight filters protect against UV radiation in the mountains and at the ocean, and they add a slight overall warming effect to the photo. Like all filters, a skylight filter should be used in conjunction with a lens hood to prevent flare caused by light reflected from the two surfaces of the filter.

Filters for Black-and-White Photography

Yellow Filters
Yellow filters are used to produce a sky that is rendered in gray tones, approximating how we perceive it to be in real life. They are also essential to obtaining correct tones in sunny snowscapes.

Green Filters
Green filters enhance the differentiation of greens in the gray scale, and darken reds, blues, and magentas. They are useful at the seaside to reproduce the sky in the correct gray tone and make brown or tan skin appear even darker. Green filters make freckles more noticeable in portraits.

Orange Filters
Orange filters darken blues and make white clouds stand out vividly against the sky. Views of distant objects are enhanced. The effect of an orange filter can be increased dramatically by adding a polarizing filter.

Red Filters
With red filters, blue sky turns deep black, clouds are offset distinctly, and everything red becomes considerably lighter. The same applies with red filters as for all other black-and-white filters—subjects of the same color as the filter become lighter, and the complementary-colored subjects (in this case, green) become darker.

The Flash System

The Built-In Flash

Canon Rebel 2000 (EOS 300), Rebel S (EOS 1000F), IIS (EOS 1000FN), XS (EOS 500), and G (EOS 500N) cameras all have a built-in flash with TTL (through-the-lens) control, making flash photography easily available at all times. By integrating the flash unit's control system with that of the camera, Canon has automated techniques previously used only by professionals. All the tedious computations and adjustments that used to seem daunting have been eliminated in programmed fill flash. Users of these cameras greatly appreciate the convenience of always having a flash unit at hand and ready to enhance a shot. Do not underestimate the usefulness of this built-in unit!

Most Rebel cameras feature a built-in flash unit, useful when you need an extra touch of light to take the shot you desire.

Guide Number

The guide number is a function of the film speed. This value for light yield divided by the shooting distance gives the aperture value required for correct exposure. Likewise, the guide number divided by the aperture value gives the distance at which a subject can be properly illuminated by the flash unit. The guide number, however, is also affected by the position of the zoom flash reflector, which allows you to adjust the zoom head's angle of illumination to the lens' viewing angle. Even though a flash emits the identical amount of light no matter what position the reflector is set at, the guide number is different at each setting. The lowest guide number refers to the wide-angle range (49 at 17mm setting for the 550EX), and the highest value (180 for the 105mm setting) to the longest telephoto range.

Learning how to use the built-in flash is easy. It is activated automatically in the Full Auto (Green Zone), Portrait, Close-Up (macro), and Night Scene modes in the Image Zone, and can be activated manually in any of the Creative Zone modes. Most Rebel-series built-in flash units have a guide number of 39 in feet (12 in meters) at ISO 100, except the Rebel IIS, which has a guide number of 46 in feet (14 in meters). This is sufficient to illuminate the viewing area of a 28mm lens on the Rebel 2000, XS, and G, and a 35mm lens mounted to the Rebel S or IIS. Particularly useful for fill-flash shots, the built-in flash ensures adequate illumination under poor lighting conditions and even in darkness; you won't have to miss a photo because a flash was not mounted and ready to shoot at the decisive moment. In addition, the built-in flash unit's recycling time is less than two seconds, allowing you to take photos in relatively quick succession.

Due to fast lenses and fast film, using a creative touch of fill flash even at long shooting distances is possible with the built-in flash. With ISO 400-speed film and a telephoto lens, the flash's range is 84 feet (28 m) at f/2, and at ISO 1000 it is almost 150 feet (50 m) at f/2. This allows you to light up an entire building or hall!

Note: When a telephoto or zoom lens is used to shoot subjects at a distance of less than 4.5 feet (1.5 m), the lens partially obstructs the path of the flash because of its length. As a result, a shadow of the lens may be projected onto the subject. Sometimes this problem can be handled simply by removing the lens hood.

Red-Eye Reduction

The Red-Eye Reduction feature on the Rebel 2000 is activated at the factory as a default setting. To deactivate it, press the function button until the arrow lights next to the eye symbol on the LCD panel, and turn the Main Dial until a 0 appears on the LCD panel. To activate Red-Eye Reduction, repeat the procedure, but turn the Main Dial until a 1 appears.

When you are ready to take the picture using the Red-Eye Reduction feature, all you need to do is to press the shutter release button halfway down and the krypton lamp will light, causing the size of the subject's pupils (and the chance of red-eye) to become reduced. Then, press the shutter all the way down to take the picture.

Like the Rebel IIS, XS, and G, the Rebel 2000 features a built-in timer (called the Red-Eye Reduction Lamp-On indicator), which lights up in the viewfinder display and LCD panel after the Red-Eye Reduction lamp has been activated. This indicator is lit for the duration that Canon recommends waiting before the shutter is released to ensure that red-eye reduction has taken effect. After that, the indicator light fades, letting the photographer know that it is "safe" to release the shutter.

Unlike previous models, the Rebel G and 2000 allow the photographer to ignore the lamp-on indicator and shoot the picture at any time. This feature is designed to make the camera more responsive for photographers who want to disregard the delay period to get the shot they're looking for without waiting for the camera to unlock the shutter release.

For best results when shooting with Red-Eye Reduction, we recommend the following:

1. Stay within 6 feet (1.8 m) of the subject.
2. Be sure that the subject is looking at the Red-Eye Reduction lamp prior to the exposure.
3. Allow the Red-Eye Reduction lamp to illuminate for at least 1.5 seconds prior to exposure, as indicated by the display of the Red-Eye Reduction Lamp-On indicator.

Fill-Flash Pictures

Flash, either built in or accessory, can be used as a key light to provide the main lighting for the subject or in combination with ambient light as fill flash to add illumination to dark or shaded areas. Fill flash can be used for two almost contradictory functions: to increase contrast, thereby making color pictures more brilliant and colorful, or to reduce high or excessive contrast between highlights and shadows.

Fill flash can also be used as "artificial sun" to improve color rendition. Low-contrast subjects in the shade or under a cloudy sky will magically receive color, and the sky or background will appear even darker and more dramatic.

Generally, all backlit subjects are good candidates for fill flash. The most beautiful backlighting occurs early in the morning and late in the afternoon, when light grazes a subject but is still quite intense. In these instances, fill flash will enhance the mood even when the background is very bright. But this is not its only positive effect. Printing will be simplified by the increased color and detail in the shadow areas; in most instances, the image quality will be enhanced considerably.

Those who have been disappointed when their subjects' faces come out too dark in their pictures will be thrilled with the results they get using fill flash. Mixing fill flash with ambient light is one of the simplest and most effective methods of achieving extraordinary results through creative lighting techniques. The glamour portrait effect of the early 1950s may not be what everyone strives for, but it is at least worth experimenting with.

If you are using the camera's built-in flash for fill in Aperture-Priority (Av) mode and are shooting in very bright conditions, the camera's maximum sync speed of 1/90 second may blink in the LCD panel. Pictures taken in this condition will be overexposed. Switch to Program (P) or Shutter-Priority (Tv) mode for better results.

Canon Speedlite Flash Units

When mounted with a Speedlite accessory flash unit, Rebel cameras offer even greater flash performance. (When a Speedlite flash unit is mounted to the camera, the built-in flash is disabled.)

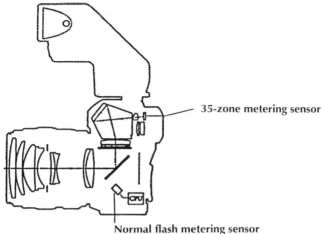

35-zone metering sensor

Normal flash metering sensor

The 35-zone exposure metering sensor, located behind the pentaprism, also determines the flash exposure in E-TTL flash mode. The normal flash exposure metering cell, located on the floor of the mirror box, is used for TTL and A-TTL flash control.

The shoe-mounted Canon EZ series Speedlite flash units feature two automatic operating modes: TTL (through-the-lens) and A-TTL (advanced through-the-lens) control. The Canon Speedlite 550EX, 380EX, and 220EX units offer E-TTL (evaluative through the lens) control, FE Lock, and FP flash with the Rebel G and 2000, and TTL mode with other Rebel models. Canon Speedlite flash units are compact, designed specifically for use with EOS cameras. These units can be used with almost all Creative Zone autoexposure modes and subject-specific Image Zone modes. Remember, though, that flash may not be appropriate for all uses, particularly when taking landscape pictures.

Canon Speedlites have a dedicated hot-shoe contact. To assure that the flash unit will make proper contact at all times, the foot has a lock wheel or sliding lock switch (as with the 220EX). If the unit has a lock wheel, make sure that it is screwed on tightly; otherwise, the locking pin on the flash foot may not engage with the flash shoe.

E-TTL Flash

Evaluative-TTL (E-TTL) automatic flash was originally introduced

with the EOS Elan II and IIE (EOS 50/50E) cameras. Now the Rebel G and 2000 also have this capability. E-TTL is available only when using the Canon Speedlite flash unit with the EX designation.

What is E-TTL? Well, TTL and A-TTL flash systems measure and control flash illumination that is reflected from the surface of the film during the exposure. E-TTL, on the other hand, uses the camera's evaluative metering sensor in combination with Canon's AIM (Advanced Integrated Multipoint) control system to read through the lens, but not off the film. Immediately after the shutter has been released but before the camera's reflex mirror is lifted, a preflash is fired. The camera's evaluative metering sensor then analyzes and compares the ambient light level with illumination reflected from the subject by the preflash. This information is used to calculate and store the flash output required for optimum exposure of the main subject (as identified by the AF system). The flash output is then controlled to provide the best possible balance between subject and background. Difficult situations that often fool other TTL systems are handled easily by Canon's E-TTL flash metering, giving you even more confidence and making flash photography easier than ever before. E-TTL works equally well with off-center subjects, too.

A-TTL Flash
Advanced TTL (A-TTL) flash control is active when an EZ series Speedlite is set for direct flash and mounted to a Rebel camera in Full Auto (Image Zone) mode or Program (Creative Zone) mode. (The 540EZ uses TTL control in all other modes; the other EZ series Speedlite flash units use A-TTL in all modes except Manual.)

Like E-TTL, A-TTL reads through the lens and concentrates its reading on the main subject (the area of the picture covered by the active focusing point). A-TTL, however, controls the flash exposure with a dedicated sensor that reads flash illumination reflected off the surface of the film during exposure. A-TTL also uses a preflash, whose reading is used in calculating an aperture value based on the distance that light must travel from the flash to the subject. The camera's computer then compares this aperture data with the ambient light-based aperture data calculated by the camera's exposure metering system and selects the smaller of the two apertures. This ensures accurate exposure of the subject in

any lighting. Any Speedlite with A-TTL capability is fully compatible with all EOS cameras.

TTL Flash

TTL flash is nearly identical to A-TTL flash control, except that it does not use a preflash. Therefore, the aperture selected in Full Auto or Program mode is based on the camera meter's reading of the ambient light. TTL flash control can be used in any exposure mode.

AF Assist Beam

The AF assist beam, whether on the camera or accessory flash unit, allows the Rebel camera's autofocus to operate even in complete darkness! By focusing on the pattern projected by this light, the camera is able to determine the shooting distance and set focus. If the subject distance is greater than the range of the AF assist beam, the AF indicator may blink in the camera's viewfinder display. When the AF indicator blinks, take your finger off the shutter release, and, if possible, get closer to the subject. A correctly exposed and sharply focused flash exposure is ensured only when a renewed touch of the shutter release does not cause the AF indicator to blink.

Which of the two AF assist beams operates varies depending on the Rebel model you're using. The Rebel S and IIS (EOS 1000F and 1000FN) do not have an AF assist beam; therefore, the Speedlite beam is activated. With the Rebel XS (EOS 500), the camera's built-in AF assist beam always takes priority over that of the Speedlite. With the Rebel 2000 (EOS 300) and G (EOS 500N), in most situations the AF auxiliary beam is emitted by the camera. If you, however, have selected the central focusing point, the Speedlite will emit the AF assist beam. And if you use a Speedlite 380EX, 540EZ, or 550EX with the Rebel 2000, the flash unit's AF assist beam will always illuminate.

Speedlite 550EX

The Speedlite 550EX is Canon's current top-model flash, with slightly more power than the 540EZ and many more features. The maximum guide number now is 180 in feet (55 in meters) with ISO 100 film.

The 550EX's zoom head reflector is automatically set to match

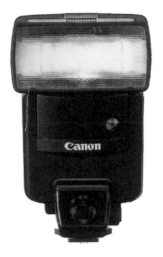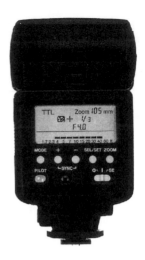

The high-performance Speedlite 540EZ is ideal for use with any Rebel-series camera.

EOS lens focal lengths of 24, 28, 35, 50, 70, 80, and 105mm. When Rebel cameras are fitted with a Canon EOS zoom lens, the position of the flash head follows the lens' changes in focal length. A built-in wide panel can be put into place manually for lenses with focal lengths as short as 17mm. Manual adjustment is required with non-EOS lenses or for special effects.

All flash functions are displayed on the LCD panel on the back of the flash unit. A green ready light (labeled PILOT) on the back of the unit indicates that the flash has been partially charged and is ready to fire within a limited range. When the light's color changes from green to red, the flash unit has been fully charged. By pressing the illuminated flash-ready light, a test flash can be fired to assure that the flash is operating normally. After a flash exposure has been made, the 550EX's exposure confirmation light (next to the flash-ready light) will light for two seconds if there is sufficient light for proper exposure.

The 550EX also offers high-speed flash sync up to 1/2000-second shutter speed, and E-TTL and FE Lock flash modes with the Rebel 2000 and G cameras.

When you are finished shooting, be sure to switch off the flash unit—something that is easy to forget. If you are shooting intermittently at a long event, the automatic Save Energy (SE) feature on the Speedlite is handy. This circuit automatically shuts off the unit to eliminate battery drain (with the 430EZ, 540EZ, and 550EX, it shuts off after about 90 seconds; with the 420EZ, after approximately five minutes). The 420EZ's LCD panel begins to blink about 30 seconds before the flash unit switches off. With any of these units, a light touch on the shutter release or pressing the flash unit's ready light will turn the flash unit's power back on.

Speedlite 540EZ

The Speedlite 540EZ is one of the Canon EOS system's most versatile flash units. It has a guide number between 52 and 177 in feet (16 and 54 in meters) at ISO 100, depending on the position of the zoom reflector.

For more information about the Canon Speedlite models 540EZ, 430EZ, 380EX, and 300EZ, refer to *Magic Lantern Guide to Canon Speedlite 540EZ.*

Speedlite 220EX

The Canon Speedlite 220EX was introduced at the same time as the Rebel G. It is a small, fully automatic flash unit featuring E-TTL flash control, FE Lock, and FP flash (high-speed sync). Although it can be used with all Rebel series (EOS 1000 and 500 series) cameras, its E-TTL feature operates only with the Rebel 2000 (EOS 300). When used with cameras that are incompatible with E-TTL flash operation, the 220EX operates TTL, taking readings off the film.

The 220EX is designed with automatic flash control only; manual flash control is not available. Its guide number is 72 in feet (22 in meters) at ISO 100, and its flash range is 2.3 feet (0.7 m) to 16.4 feet (5 m). The 220EX's coverage is adequate for a 28mm lens. It can recycle from 0.1 to 4.5 seconds.

Other features include an autofocus assist beam that is linked to the camera's center focusing point, a flash confirmation lamp that lights green if there is enough light for proper exposure, an easy-to-slip-on foot with a locking switch, and a Save Energy feature, which conserves battery power by turning the flash unit off 90 seconds after the unit was last in operation.

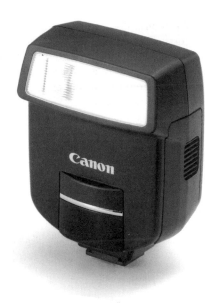

The Canon Speedlite 220EX features E-TTL flash metering.

The flash unit is powered by four AA alkaline-manganese, NiCd, or lithium batteries.

At 2.6 x 3.6 x 2.4 inches (6.6 x 9.1 x 6.1 cm) and 5.6 ounces (160 g), the 220EX is compact and automatic, a suitable companion to any Rebel-series camera.

Using Flash in Program (P) AE or Full Auto Mode

The Rebel 2000 offers 35-zone evaluative metering for flash pictures. The area covered by the active AF point is given the most weight by the camera's computer, but the surrounding areas are also analyzed and considered in the metering calculations for proper flash exposure.

When you first start out with this camera, it may be hard to remember all of its programs and their features. We therefore recommend that you initially concentrate on one or two modes, using either Full Auto (Green Zone) mode or Program (P) AE mode to start. Then, step by step, you can explore other modes, each of which offers effective creative alternatives.

Shooting with any Rebel camera and flash is easiest when the camera is set in Full Auto mode, the lens is set to AF, and the flash unit is on A-TTL mode. After that is done, all you have to do is aim at the main subject through the AF metering field, lightly touch the shutter release, and observe the green numbers and symbols at the base of the viewfinder display. Normally, the camera works with flash at a sync speed of 1/90 second. If the flash-to-subject distance exceeds the range of the flash, the flash unit's exposure confirmation lamp will not illuminate after the exposure has been made, and the photo will be underexposed.

Using Flash in Aperture-Priority (Av) Mode

Some photographers still think that the light of an electronic flash will destroy the entire mood of a picture. Of course, there are many cases when it makes sense to reach for high-speed films and not use flash illumination. But once the eye has been trained to recognize the details of using light, even those situations can often be enhanced with a touch of flash, resulting in technically improved and more expressive photos.

One way to achieve this is in Aperture-Priority (Av) mode. By lightly pressing the shutter release, the shutter speed required for the standard aperture value of f/5.6 is set. Should a different aperture value make more sense for the task at hand (such as controlling depth of field), it can be adjusted and the shutter release pressed again lightly to set a new shutter speed automatically.

Using Flash in Shutter-Priority (Tv) Mode

In Tv mode, you select the shutter speed. This speed should not exceed 1/90 second, because at faster speeds, depending upon the flash unit in use, only part of the image area could be illuminated. With a Canon Speedlite mounted, however, if a shutter speed faster than 1/90 second is inadvertently set, the Rebel 2000 camera will automatically reset the shutter speed to 1/90 second. Times slower than 1/90 second can always be set.

Mount the flash unit to the camera and set the Command Dial to Tv. When the shutter release is pressed lightly, the aperture

value, determined and set by the camera based on the level of available light, will appear in the viewfinder. If this value is blinking, adjust the shutter speed until the blinking stops, then take the picture.

When using flash, exposure values are determined by the total amount of existing light. Flash is added to this basic brightness. A technically perfect flash picture can be made with an exposure of 1/30 second or 30 seconds, but there is a world of creative difference between the two. The flash can act as the main light source and be used in conjunction with long time exposures to create special effects. You can set a slow shutter speed, which will enhance the mood offered by the existing ambient light, or use a faster shutter speed, which will create a mood of intensity by using key flash.

For example, let's say you want to take a portrait in the living room with a mood evoking a quiet evening. If you use Program mode, the camera's automatically selected flash sync speed of 1/90 second would be too fast to record the ambient light illuminating the surroundings. Only the subject within the range of the flash would be recorded, and the background would be very dark because the ambient light would be much too weak to register at that shutter speed. But by using Shutter-Priority mode in this case, you can set a shutter speed slow enough to record the ambient light in the background. The flash would light only the foreground subject, serving as fill-in illumination. The picture forms a portrait that reflects the mood of its environment.

This flash technique is even more effective and impressive for shooting outdoors—at early dusk, for example—with high-speed film. By using Shutter-Priority mode, you can capture a mood-enhanced picture. A touch of flash light adds color to the picture for subjects that fall within a range of 90 to 120 feet (30 to 40 m).

Special Flash Effects
The portrait shot described above is best taken while using a monopod or tripod, which facilitates making the foreground and background as sharp as possible. This effect, however, may not be wanted. If you are taking a picture of a street performer, you may want the subject to appear more dramatic and abstract. To achieve a blurred background, extend the exposure time and take the photo holding the camera. Following the burst of flash, move the

camera slightly over the duration of the exposure period while the shutter is still open. This will produce a sharp image of the subject (illuminated by flash) with a correctly exposed but slightly blurred background, creating an exceptional special effect.

Should this result still not be interesting enough, filters can be used on the camera and/or the flash unit for creative effects (see Filters chapter). For instance, if complementary-colored filters (such as red and green) are placed on the camera and flash unit, the background will pick up the color of the lens' filter, while the subject's color will appear natural. If a filter is placed over just the flash unit, the subject will pick up the tint of the filter and the background will appear natural. There are no limits to the effects you can produce with flash.

Using Flash in Manual (M) Mode

The Manual (M) mode adjustment of aperture and shutter speed is required in certain situations when precision settings are necessary. If the camera is set to M, the Speedlite flash unit will automatically switch to TTL, indicated on the flash unit's LCD panel. It also displays the flash unit's working range for the film loaded in the camera and the standard aperture of f/5.6. Because a change of aperture will affect the working range, these values will change immediately with each new setting.

Stroboscopic Flash Techniques

The progression of motion can be captured by recording several individual images on one frame. The Canon Speedlite 550EX, 540EZ, 430EZ, and 420EZ can create such stroboscopic effects automatically. The maximum number of flash exposures is a function of battery power and software built into the flash unit. An accessory battery pack is recommended for maximum performance of the 550EX, 540EZ, and 430EZ Speedlite flash units.

Follow this procedure for taking strobe exposures: First, set the Command Dial to M (Manual mode). Set the shutter speed at least to one second, but can exceed 30 seconds using the Bulb setting. Select the aperture manually. Set the Speedlite flash unit

to MULTI using the mode button. Press the sel/set button, and use the +/– button to select the power level, frequency of flash bursts (Hz), and number of bursts, which will be displayed on the flash unit's LCD panel.

The Canon Speedlite 550 EX/540EZ allows programming of up to 100 exposures per second, the 430EZ allows up to 10, and the 420EZ allows up to five. This high-speed flash sequence, of course, requires considerable power. Therefore, such flash exposures can be made only at 1/4, 1/8, 1/16, 1/32, 1/64, and 1/128 of the maximum power with the 540EZ and at 1/4, 1/8, 1/16, and 1/32 power with the 430EZ and 420EZ units. The flash unit's display will indicate the greatest possible shooting range for the set aperture. When the ready light on the flash unit lights up in red, you can take the strobe picture.

Soft Light with Bounce Flash

Most accessory flash units have relatively small reflectors and thus a relatively acute angle of reflection (compared to professional lighting systems). Consequently, light is more direct and covers a smaller area. When flash light is aimed directly at the subject, it can create deep, harsh shadows.

The Speedlite 420EZ, 430EZ, 480EG, 540EZ, and 550EX's versatile tilt-and-swivel heads (the 380EX features tilt only) can be used to modify this effect. Softer lighting effects can be obtained when the light makes a detour by first bouncing off a wall or ceiling.

The texture and dimension provided by flash illumination do not suffer noticeably, and the shadows become softer. The EOS TTL metering systems always measure light reflected by the subject and are therefore equally effective whenever bounce flash, A-TTL mode, or E-TTL mode is used.

This flash technique requires that you observe the information displayed in the viewfinder carefully. Because the light is not traveling along the shortest path to the subject, the limits of your flash unit's range may be reached relatively quickly due to the total distance the light must travel.

Bounce flash offers many advantages in many different picture-taking situations. For example, it prevents red-eye, which results when the flash unit is relatively close to the optical axis of the

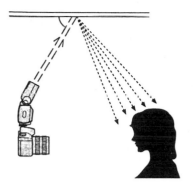

Bouncing flash off a wall or ceiling diffuses the light and reduces the harsh glare that often results from direct flash illumination.

lens. By redirecting the flash unit's axis, red-eye is eliminated. Also, bounce flash can be used to soften illumination in portraits. To optimize this effect, make sure that the bounce surface is as close as possible to the flash unit. If you are using bounce flash to illuminate a large room, best results are achieved when the ceiling or wall that the flash is bouncing off of is 6 to 9 feet (2 to 3 m) from the flash unit. Using the flash head's wide-angle setting (if it has one) reduces total brightness and at the same time improves the light quality.

Accessories

The accessories listed and described below are compatible with all Rebel 2000, S, II, IIS, X, and XS (EOS 300, 500, and 1000 series) cameras unless otherwise specified.

Focusing Magnifier S
For extremely precise manual focusing, Canon offers a special focusing magnifier that is slipped onto the viewfinder eyepiece. The Magnifier S enlarges the center of the image by 2.5x, and can be folded up for normal viewfinder use. It comes in a kit, which includes the magnifier and the Adapter S, a square adapter that is mounted to the eyepiece. Those who already have a focusing magnifier for the Canon F-1 need only purchase the square adapter. Photographers who wear eyeglasses can adjust the eyepiece to correct their vision within a range of –4 to +4 diopters.

Angle Finder B
The Angle Finder B provides an unreversed image that is viewed at right angles to the camera's eyepiece. This finder is useful for copy work or when shooting close to the ground. The finder, which can be rotated so that it can be looked into from either side of the camera or from the bottom, features dioptric eyesight correction in the range of +2 to –4 for those who wear eyeglasses. This finder weighs 4.2 ounces (120 g).

Dioptric Adjustment Lenses
Canon makes ten dioptric adjustment lenses (series E), from +3 to –4 diopters, to adapt the viewfinder image to the photographer's visual requirements. The Rebel (EOS 1000, 500, and 300 series)

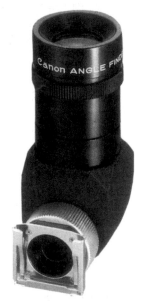

Canon Angle Finder B

cameras' viewfinders have an inherent correction of –1 diopter. The dioptric adjustment lenses made by Canon are identified not by the diopter value of the lens itself, but their value in combination with the camera's –1 diopter viewfinder system. For example, an adjustment lens designated +3 is actually +4 alone, but gives a +3 correction on the camera.

To use a Dioptric Adjustment Lens E, the camera's standard eyecup must be replaced by a special frame, the Rubber Frame Eb, which accepts any of the 10 dioptric adjustment lenses.

Eyepiece Extender EP-EX15
This extends the eye's distance from the viewfinder by 5/8 inch (15 mm), to keep the photographer's nose from hitting the camera body. The viewfinder image size, however, is decreased by 30%.

The Eyepiece Extender EP-EX15 increases comfort, but decreases image magnification.

Grip Extension GR-70
This grip extension, which has a padded strap, is designed for people with large hands who find the standard grip on Rebel (EOS 1000) and Rebel II (EOS 1000N) series models to be too small.

Grip Extension GR-80TP
An accessory particularly recommended for the Rebel 2000 (EOS 300), X, and XS (EOS 500

The Grip Extension GR-80TP, which has a built-in tripod, is compatible with the Rebel X, XS, G, and 2000 (300 series).

series), this grip includes a built-in tripod for close-up, self-timer, and slow shutter speed shots. Although not actually designed for the early Rebel (EOS 1000 series) models, it will work with them fairly well.

Remote Switch RS-60E3
This new cable release is compatible with the Rebel 2000 (EOS 300) and the G, X, and XS (EOS 500 series). It plugs into the camera's remote-control socket and is intended to prevent camera shake when the shutter is released. Especially useful for macro photographs and long exposures taken with a tripod, it has a locking switch that allows the shutter release to be held open indefinitely for time exposures in the Bulb setting.

Remote Switch RS-60E3

Off-Camera Shoe Cord 2
This two-foot (6 m) coiled cord, with a camera adapter on one end and a flash adapter on the other, enables the photographer to use a Speedlite flash off-camera (for example, on a flash bracket) while still maintaining all dedicated flash functions.

Battery Pack BP-200
This battery pack is compatible only with the Rebel 2000 (EOS 300); the older BP-8 fits the G, X, and XS (EOS 500 series). It functions as both a vertical grip and an accessory power source, taking four AA alkaline-manganese or NiCd batteries.

Camera Cases and Bags
Canon offers an assortment of fitted "everready" cases to accommodate several different lenses mounted on the various Rebel cameras.

Domke F-3X Super Compact Bag

Another alternative that offers added flexibility are camera bags such as those made by Domke®. A number of sizes and styles are available to hold extra lenses, a flash unit, accessories, film, and even this book! Domke bags were designed by a professional news photographer, so they are comfortable to carry and highly accessible in the field.

There are many other brands and varieties, including hardshell cases that resemble suitcases. A case of this type is ideal if you're boating or traveling in the tropics or desert because it is well sealed against water, humidity, and dust. It may not be the best choice, however, if you are going to walk any distance with your equipment. Even with a shoulder strap, it is not comfortable to carry. A "fanny pack" like the Domke OutPack® Waist Pack or the F-5XB Shoulder and Belt Bag is a good choice for hiking, backpacking, or cross-country skiing.

When purchasing a camera bag, think about the amount of equipment you intend to carry and your picture-taking style. Choose a bag that is larger than you currently need so it will be big enough to hold a second flash unit or any new lenses acquired later.

A completely waterproof bag cannot be made, but it should at least be adequate to keep the equipment dry in rain, snow, or dense fog. The bottom of the bag should be reinforced so it can be carried with a heavy load. Equipment dividers should be padded to protect valuable equipment from banging around. Well-designed Domke-patented dividers have sewn-in bottoms to eliminate equipment from "wandering" and to make equipment changes from one bag to another quick and easy.

Also from Silver Pixel Press

Magic Lantern Guides—take you beyond the instruction manual.

KODAK Books—great picture-taking advice from the foremost name in photography!

KODAK Pocket Guide to 35mm Photography (AR-22)
On-the-spot answers to almost any photographic question. Explains cameras, filters, special effects, and more! Softbound, 3-1/2 x 6-1/4". 112 pp. ISBN 0-87985-769-2. $7.95 USA

KODAK Guide to 35mm Photography (AC 95)
For the beginner to advanced amateur, this complete guide covers basic principles, camera handling, flash techniques, lenses, composition, filters, close-up photography, films, and lots more. Softbound, 6 x 9". 272 pp. ISBN 0-87985-801-X. $19.95 USA

Winning Pictures: 101 Ideas for Outstanding Photographs (AC-200)
A creative subject-by-subject approach to taking outstanding photos. Includes tips, hints, and unique suggestions, along with a wealth of technical information. Over 100 inspiring examples. Softbound, 8-1/2 x 11". 116 pp. ISBN 0-87985-761-7. $15.95 USA

The KODAK Workshop Series
This respected library offers the amateur photographer practical information for taking professional-quality photographs.

The Art of Seeing: A Creative Approach to Photography (KW-20)
This book breaks through creative barriers with advice on looking at the world through photography. It shows you how to make better photos by taking advantage of principles of composition, lighting, color, form, and viewpoint. Softbound, 8-1/2 x 11". 96 pp. ISBN 0-87985-747-1. $17.95 USA

Close-Up Photography (KW-22)
Expand your photographic horizons by getting up close. This book tells you everything you need to know about equipment, lighting, films, depth-of-field controls, controlling movement, foreground and background, plus sections on close-up photography of hobbies and crafts. Over 130 illustrations. Softbound, 8-1/2 x 11". 96 pp. ISBN 0-87985-750-1. $14.95 USA

Existing-Light Photography (KW-17)
Recommendations for taking photos in typical existing-light situations, such as sporting events, museums, theaters, and night scenes. Covers high-speed films, camera handling, lighting, and filters. With tables for exposure and filtration recommendations. Over 200 illustrations. Softbound, 8-1/2 x 11". 88 pp. ISBN 0-87985-744-7. $19.95 USA

Electronic Flash (KW-12e)
The major sections in this comprehensive book cover: when to use flash, the nature of light, flash basics, electronic flash control, accessory flash, film and filters, creative control, and putting flash to work. Includes a troubleshooting section, a glossary, and appendices that cover maintenance and flash performance. Softbound, 8-1/2 x 11". 110 pp. ISBN 0-87985-772-2. $22.95 USA

Lenses for 35mm Photography (KW-18)
This valuable reference provides information on lens characteristics, optical performance, special-purpose lenses, lens accessories, maintenance, and how to buy new or used lenses. Over 250 illustrations. Softbound, 8-1/2 x 11". 112 pp. ISBN 0-87985-765-X. $22.95 USA

Using Filters (KW-13)
Gives creative and technical advice on how filters work and how to use them to create exceptional images in color and black and white. Over 180 illustrations. Softbound, 8-1/2 x 11". 96 pp. ISBN 0-87985-751-X. $14.95 USA

Notes

Notes